JEAN MICHEL BASQUIAT

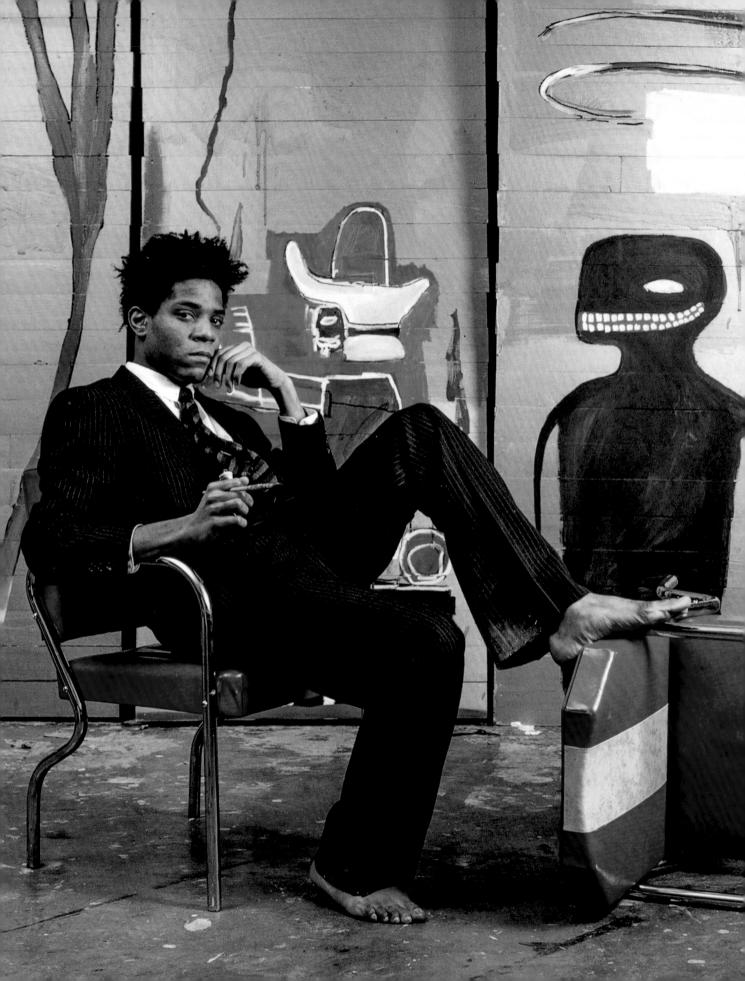

Leonhard Emmerling

Jean-Michel Basquiat

1960–1988

The Explosive Force of the Streets

TASCHEN

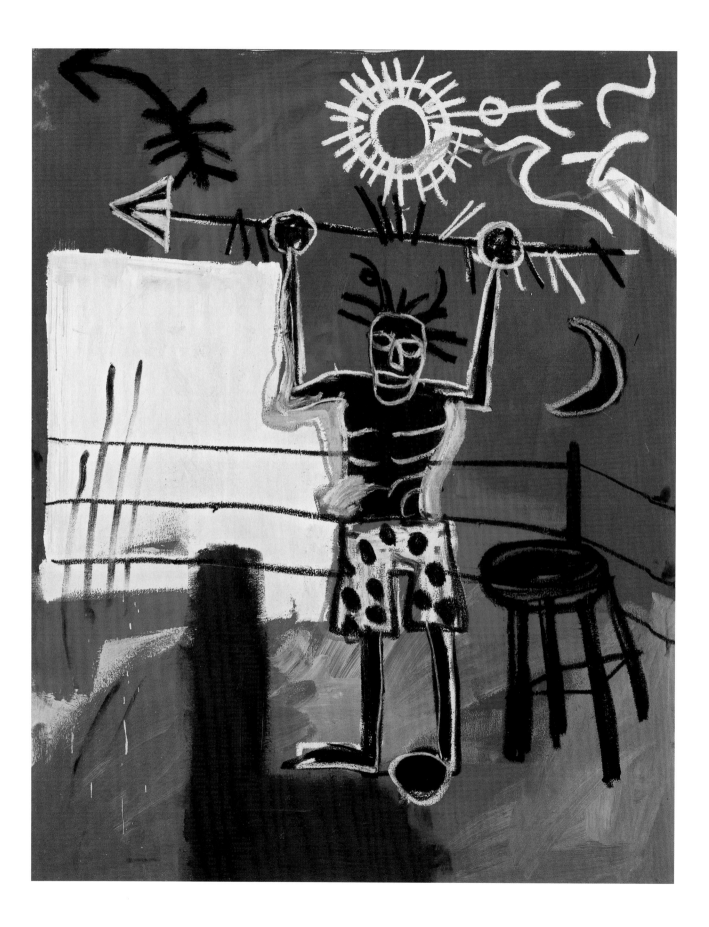

Contents

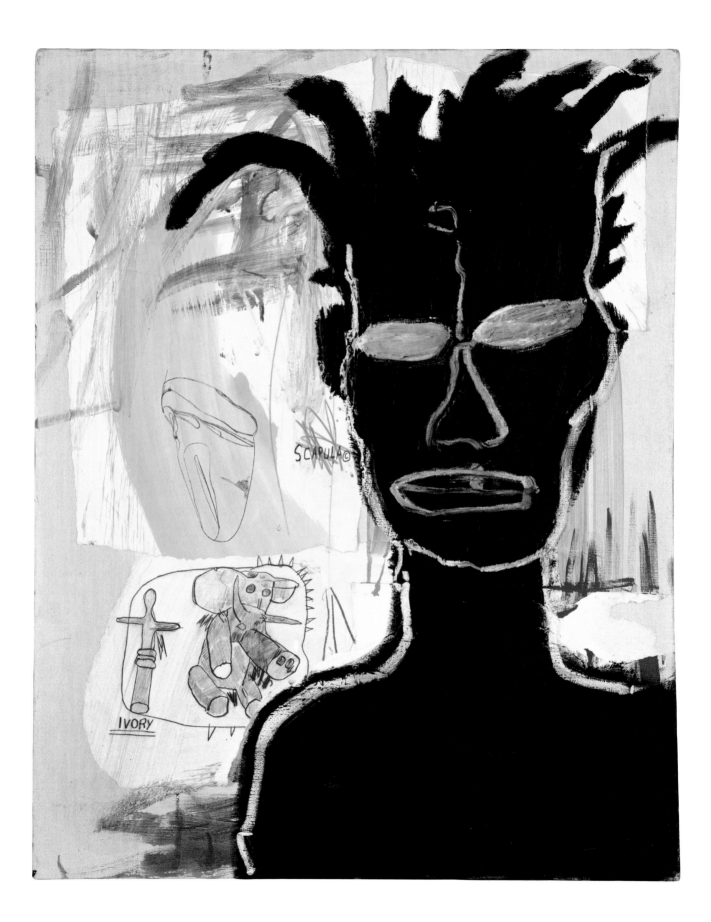

"Pay for Soup. Build a Fort. Set That on Fire."
Basquiat and the 1980s Art Scene

Jean-Michel Basquiat's life and career as a painter are nearly paradigmatic for the riddles of the art world in the 1980s. His rise to prominence was without parallel. The graffiti sprayer, who left mysterious and witty statements on the walls of SoHo and the East Village using the pseudonym SAMO, became a celebrated star, holding court in the explosive art scenes of Zurich, New York, Tokyo and Los Angeles. He was courted and in the end worn down by an art market that saw prices shoot up to previously unimaginable heights as its mechanisms followed increasingly cutthroat and purely economic laws. Driven by an insatiable hunger for recognition, fame and money, wavering between megalomania and an insurmountable shyness, plagued by self-doubt and self-destructive impulses, Jean-Michel Basquiat died of an overdose on August 12, 1988, aged just 27. He had flashed through the creative heavens, his works sold by such prominent art dealers as Mary Boone, Larry Gagosian and Bruno Bischofberger, and he flickered out suddenly, before his artistic star could reach its full brilliance.

His life, its feverishness, his meteoric rise and early death all lend themselves fabulously to the mythmaking of Basquiat as the epitome of a noble fallen genius, the artist as exemplary outsider. Since the days of Romantic art, a visceral notion of the artist driven by his urge to create has been associated with psychic instability, social isolation and, as the necessary ultimate consequence, failure. This image has been shaped by painters like Vincent van Gogh, who was denied recognition in his lifetime and who mortally wounded himself as "a suicide by society" (in Antonin Artaud's words) with a shot to the chest on July 27, 1890. The same cliché was also served by the fate of Jackson Pollock, remitted to psychiatric treatment due to alcohol problems starting in 1937 and dying after a car crash in 1956.

But Basquiat's fame is not cemented simply in cultural schemata and obsolete ideas of genius. Next to the actual quality of his painting, we must recall the situation of the art world when Basquiat entered the scene in the early 1980s. In the United States, artistic developments and the art market in the 1970s were dominated by the Pop art of Roy Lichtenstein, Claes Oldenburg, Robert Rauschenberg and Andy Warhol, as well as the rise of Concept art and Minimal art. Although the public had tired of the hermetic steel-plate arrangements of Carl Andre, the industrial boxes of Donald Judd, the mathematic speculations of Sol LeWitt, and the conscious avoidance of any statement in the painting of Frank

Untitled, 1984
Acrylic, oilstick, marker, graphite, and photocopy collage on canvas, 76 x 61 cm (30 x 24 in.)

SAMO, 1978
Ink on paper, 30.5 x 23 cm (12 x 9 in.)

Stella, the nation's museums had ceased to pay any attention to new ideas or movements. That task was taken over to an increasing degree by the galleries, who looked hopefully to Europe, where a renaissance had begun to challenge the decades-old notion that painting had died. In Italy, the Transavantgarde movement arose with the works of Sandro Chia, Francesco Clemente, Enzo Cucchi and Mimmo Paladino. Germany gave rise to a movement known as the Young Wild Ones (Die Jungen Wilden), as Georg Baselitz, Jörg Immendorff, Markus Lüpertz, A. R. Penck and Salomé helped to popularize a neo-expressive, figurative style of painting. A younger generation was responding to the intellectual coldness of conceptual and minimal painting with emotionally charged pictures that did not fear to conjure romantic images of the world, and that did not disguise their debt to the idealism of German Expressionism. Sigmar Polke and Gerhard Richter spearheaded a return to the medium of painting, which had been defamed as "bourgeois" and as socially irrelevant by the exponents of non-painterly forms – although these had grown just as comfortable with the kind of self-contained, artificial speculations they associated with painting, especially the figurative kind.

All this came at a time when the art market began to boom. Buying art was chic and art became an object of investment, just like shares in stocks. Charles Saatchi is the best known of those collectors who began to buy art in the 1980s, a man who still possesses the power to determine the path of an artist's career today. The high and mighty of American society were no longer satisfied with their tradition of genteel sponsorship of museums (which they saw merely as a duty to the community). They increasingly found it obligatory to seek out fashionable galleries on the weekends, to attend openings or visit artists in their studios. Art became part and parcel of lifestyle. Fueled by the fear of not being on top of the times, collectors bought whatever was being stoked as the latest non plus ultra. Suddenly, potential collectors actually had to get themselves on

SAMO© graffiti, New York 1979
Photo Henry Flynt

waiting lists to buy from some of the newest painter idols, like Eric Fischl, Julian Schnabel und Keith Haring. This gave rise to an absurd situation, in which artists started producing according to the laws of supply and demand. The disastrous results of this system on artists' lives and careers soon became obvious. Where before the goal was to get one's best works into museums, the object now was simply to sell, sell, sell, indiscriminately. The defining works of a career routinely landed in the troves of private collectors, only to reappear on the market two or three years later, commanding prices that no museum could bear.

The dividing line between high and trivial culture, which Pop art had already questioned and transgressed, now became increasingly porous. Although the connection between the art scene and the music industry was first established in the 1960s, the 1980s forged an unprecedented bond between art, music and nightclubs. Mudd Club, Area, the Palladium and Club 57 became famous meeting places for all the rich and nouveaux riches who wanted to play a role in the society life of New York City. This liaison between high and trivial culture was very much the achievement of one man, Andy Warhol. He was the first to succeed in mixing the once strictly separate worlds of high culture and ordinary life, until they became practically indistinguishable. His life swung freely between art and glamour, as was evident in every aspect of his public persona: he was neutral about accepting patrons who wished portraits from him, from art collectors like Peter Ludwig to football players like Franz Beckenbauer and nameless transsexual beauties of the night. As a publisher, Warhol pioneered a very special type of yellow press exemplified by his magazine, *Interview.* In all of these choices, Warhol paved the way for developments from the 1980s to the present day – in which the combination of fashion, design, art and glamour has become self-evident.

Jean-Michel Basquiat on the set of *New York Beat/Downtown 81*, New York 1980/81
Photo Edo Bertoglio

PAGE 11
Pay for Soup, 1987
Acrylic and oilstick on canvas,
125.5 x 100.5 cm (49½ x 39½ in.)

PAGES 12/13
Acque Pericolose (Poison Oasis), 1981
Acrylic, oilstick and spray paint on canvas,
167.5 x 243.5 cm (66 x 96 in.)

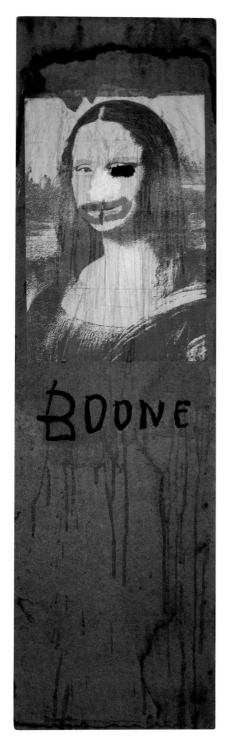

Boone, 1983
Paper collage, marker, and oilstick on masonite
mounted on panel, 104 x 30.5 cm (41 x 12 in.)

Boone, a nasty paraphrase of the most famous
painting in the world, Leonardo da Vinci's
Mona Lisa, is a dubious homage to Basquiat's
gallerist of some years, Mary Boone, with
whom he had a hostile final break, as with
so many others.

The boom in the art world was advanced by a new type of gallery owner.
By controlling the way in which an artist was promoted, this new art merchant
also defined the rules of the game by which prices were set and manipulated.
Mary Boone, who represented Basquiat for two years (ill. p. 10), understood per-
fectly how to use the media to get people talking about her gallery and her per-
son. Suddenly, magazine covers and headlines were no longer the monopoly of
celebrities from show business – they had to make room for a new type of celeb-
rity from the art scene. Typical of the new scene was the Zurich-based dealer
and collector Bruno Bischofberger, who dealt Andy Warhol's work and who
briefly took on the exclusive rights for Jean-Michel Basquiat. Once a month, he
flew Concorde to New York, where he went on extensive shopping sprees, buy-
ing art in previously unprecedented volumes from galleries and studios. One of
his assistants has since reported seeing millions of dollars in cash and art change
hands in a day's transactions. By selling and repurchasing works, only to sell
them again at the next opportunity, Bischofberger drove prices up to unbeliev-
able heights. Art was no longer a polite, gentlemanly business, where move-
ments and ideas could be influenced from the background in the mode of
Daniel-Henry Kahnweiler or Pierre Matisse. The art dealer became a perma-
nent, media-hungry star, and his or her business plan determined the direction
of contemporary art from the forefront.

The booming art market produced a brood of new galleries, many of which
ran more on enthusiasm than on a true understanding of art. Next to SoHo, the
1980s also saw the brief establishment of the East Village, home turf of the radi-
cal scene, as a new Mecca for art collectors. This movement east of the Bowery
was directly connected to the marketing of graffiti art. Contrary to the hype,
graffiti was not simply the angry art of black kids from the Bronx, tagging their
names on buildings and subway cars as a way of protesting their isolation and
impoverishment. In reality, the graffiti phenomenon ignored distinctions of race
and class. If we must attribute graffiti to a particular social class, then to the sec-
ond-generation offspring of immigrants from the Third World and Europe,
whose parents tended to be lower middle-class. When Basquiat started out with
wall graffiti under the pseudonym SAMO in 1978 (ill. p. 8), the anarchic mass
movement of spraying had already passed its peak, and was well on its way into
galleries and the art market. Kenny Scharf, Fred Brathwaite, Lee Quinones and
Rammellzee were no longer youthful ne'er-do-wells chased by the cops, but rath-
er artists of distinctive reputation.

In the course of the 1980s, the separation between artwork as artwork and
artwork as monetary value became obsolete, much as we might prefer not to
confront that reality. The artwork becomes interchangeable with non-artistic
techniques and promotional tools, like posters and photos of oneself, which had
the ability to impress and elicit emotion just as powerfully as the artwork itself.
Understanding the situation of Basquiat is difficult, insofar as we cannot assume
that he ever held control over the marketing of his own work. And it was not just
his work that was marketed, but also the image of Jean-Michel Basquiat himself,
as the only black artist to achieve the Olympian pinnacle of international painter
stars, in an art world defined mainly by price tags. Without a doubt, a large part
of his initial financial success, as well as of his later downfall, can be traced to the
latent racism of the New York art scene, and to how its white people reacted to
the color of Basquiat's skin.

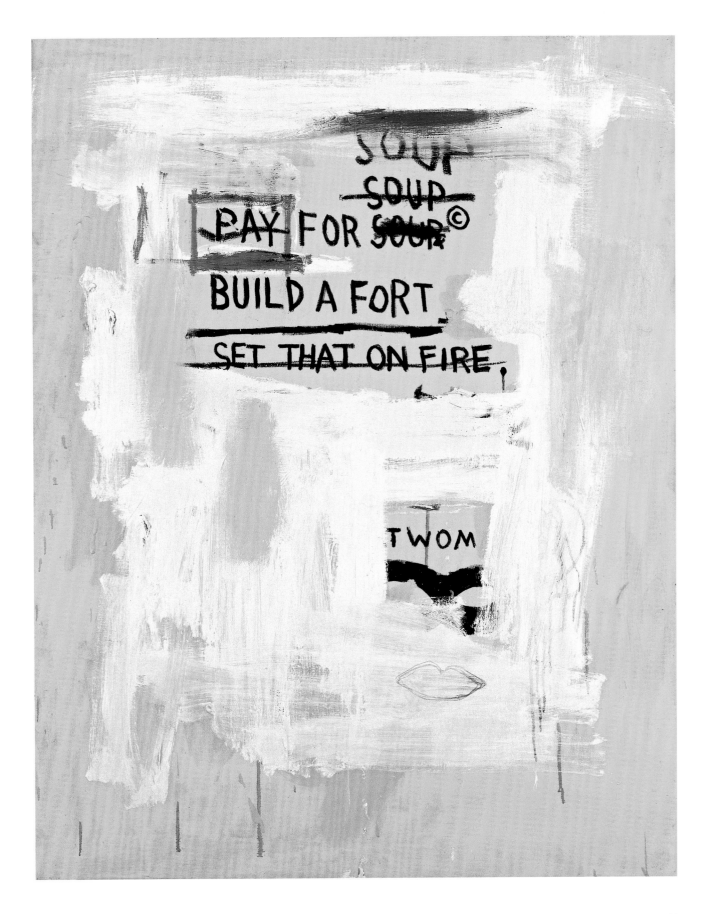

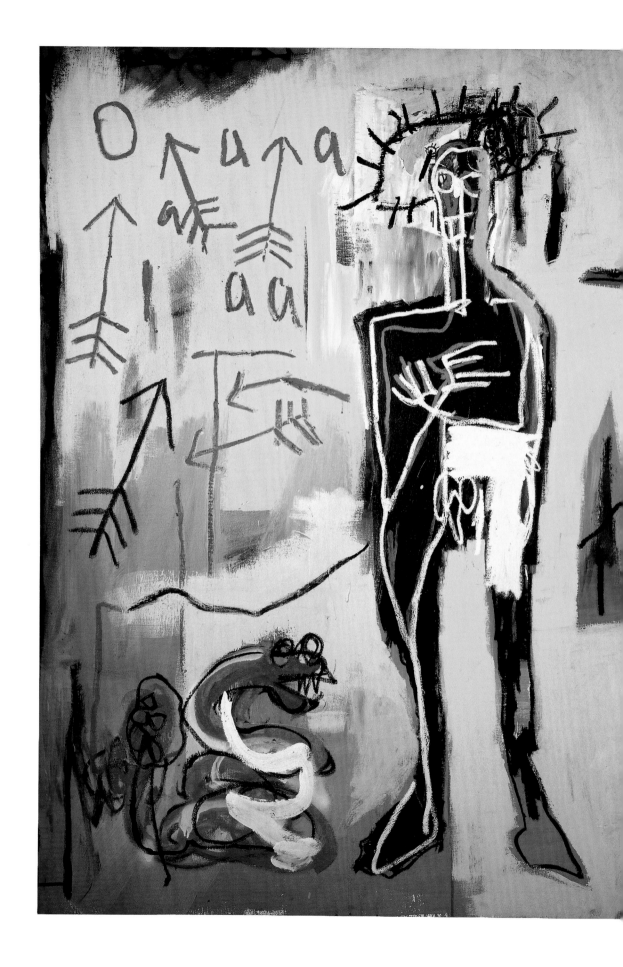

13

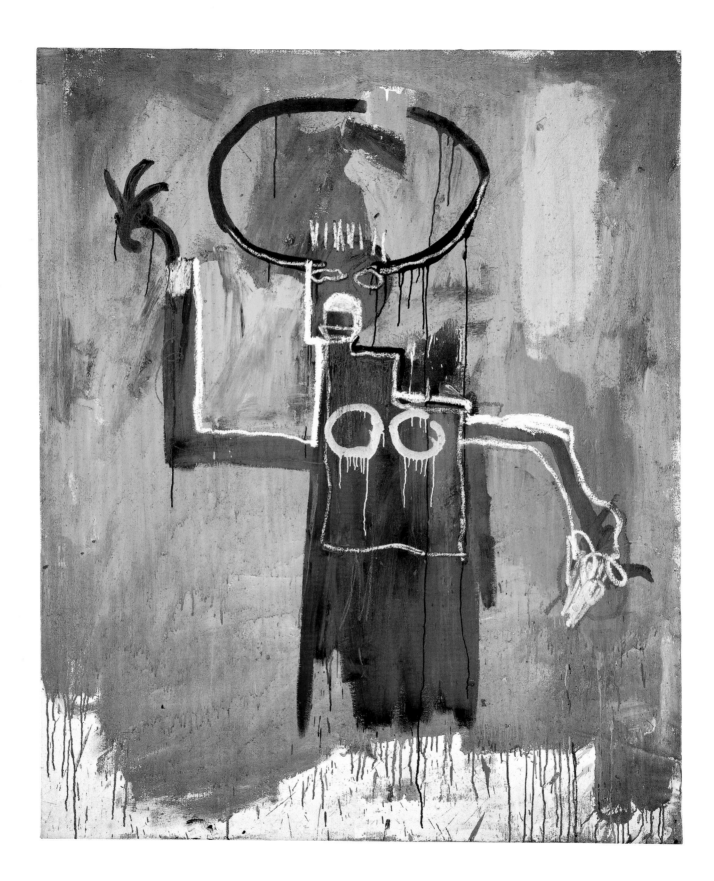

"SAMO as a Neo Art Form"
Childhood and Youth

Jean-Michel Basquiat was born on December 22, 1960, in Park Slope, a comfortable residential section of Brooklyn. His father, Gerard, came from Haiti; his mother, Matilde, was born in Brooklyn of Puerto Rican parentage. His sisters, Lisane and Jeanine, were born in 1963 and 1967, respectively. His mother, who spoke English and Spanish, taught Basquiat these languages and took him on trips to visit the city's museums. Jean-Michel's musical influences also came from her and from her parents. In 1981, Basquiat honored his grandmother Flora with the Spanish-titled painting *Abuelita*, meaning "grandmother" (ill. p. 15).

At the age of seven, Basquiat became the victim of a traumatic accident. He was hit and run over by a car while playing in the street and rushed to a hospital. An arm was broken and he suffered a number of internal injuries, one of which required the removal of his spleen. To help him pass the time, his mother gave him the classic anatomical work *Gray's Anatomy* (1878). No doubt the oft-repeated themes in Basquiat's works of internal organs and human skeletons owed much to this event, and to the influence of the anatomy book, which he studied passionately during his hospital stay.

Basquiat's school career was not very successful, nor did it run particularly smoothly. He kept changing schools, and, where art was concerned, he was himself not at all satisfied with his draftsmanship, as he reported in 1983 in an interview with Henry Geldzahler.

The birth of SAMO, the pseudonym with which Basquiat signed his sprayings in SoHo, came with the founding of a school paper in the spring of 1977. For the paper Basquiat drew a comic about a young searcher for truth, who wishes to find a new, contemporary approach, but who is instead confronted with a false priest who attempts to sell him on the great world religions. Finally, the pseudo-religion of SAMO takes hold of the young man (ill. p. 16).

Basquiat told the *Village Voice* in 1978 that SAMO was created while he and his school friend, the graffiti artist Al Diaz, smoked marijuana. Basquiat, inebriated, mentioned something about "SAMe Old Shit." SAMO is then an acronym, a corrupted shortening. Whatever its roots, the idea of SAMO grew from its beginnings, as the kernel of a lifestyle religion devoid of all ethical substance, to a grand experiment in semiotics with its own language of truncated sentences. Beginning in May of 1978, this system of phrases, in spray-painted form, found

Abuelita, 1981
Mixed technique on paper,
100 x 70 cm (39¼ x 27½ in.)

Untitled, 1981
Acrylic and oilstick on wood,
115.5 x 109 x 72.5 cm (45½ x 43 x 28½ in.)

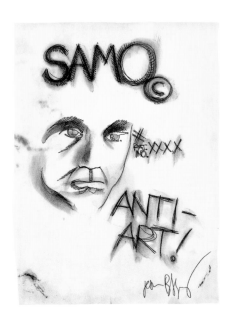

Untitled (SAMO/Anti-Art), 1979
Felt-tip pen, pencil and pen on paper,
26.5 x 20.5 cm (10½ x 8 in.)

itself applied to the Brooklyn Bridge, to the neighborhood of the School of Visual Arts, and to the area around the Mary Boone Gallery, in SoHo and Tribeca. "SAMO as a new art form. SAMO as an end to mindwash religion, nowhere politics and bogus philosophy. SAMO as an escape clause. SAMO saves idiots. SAMO as an end to bogus pseudo intellectual. My mouth, therefore an error. Plush safe… he think. SAMO as an end to playing art. SAMO as an alternative 2 playing art with the 'radical chic' set on Daddy's $funds."

The SAMO project attacked the speciousness of materialist society. Basquiat and Diaz used their made-up religion as a substitute for all the value systems which they felt had falsely represented them, these ideas and systems in truth connoting no more than base economic interests. In essence, the SAMO religion was a retort against the way in which society uses values and ideals, an art product tailored to a starched society.

At the same time, Basquiat did not shy from directly insulting exactly those persons whom he wanted to contact through his graffiti; indeed, these are the same individuals who later bought his art with the "dollars from papa" he so roundly lambasted. His message was directed at the art yuppies cruising the gallery districts in their convertibles; fascinated by the "radical chic" of the avant-garde, they began to exploit it, using its supposed high-brow causticity merely as a decoration for their lifestyles. SAMO, often coupled with a copyright sign, quickly became as famous as Keith Haring's "Radiant Baby." Sadly there are few photographs of Basquiat's graffiti oeuvre; in 1980, Basquiat imitated his

Untitled, 1980/81
Acrylic, spray paint, and oilstick
on canvas, 122 x 122 cm (48 x 48 in.)

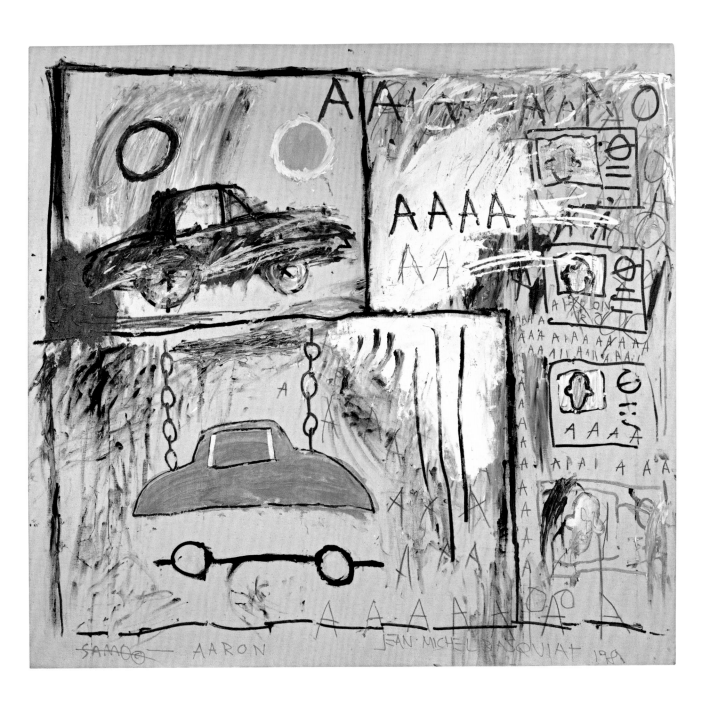

Cadillac Moon, 1981
Acrylic and oilstick on canvas,
162 x 172 cm (63⅞ x 67¾ in.)

PAGES 18/19
Boy and Dog in a Johnnypump, 1982
Acrylic, oilstick, and spray paint on canvas,
240 x 420.5 cm (94½ x 165⅝ in.)

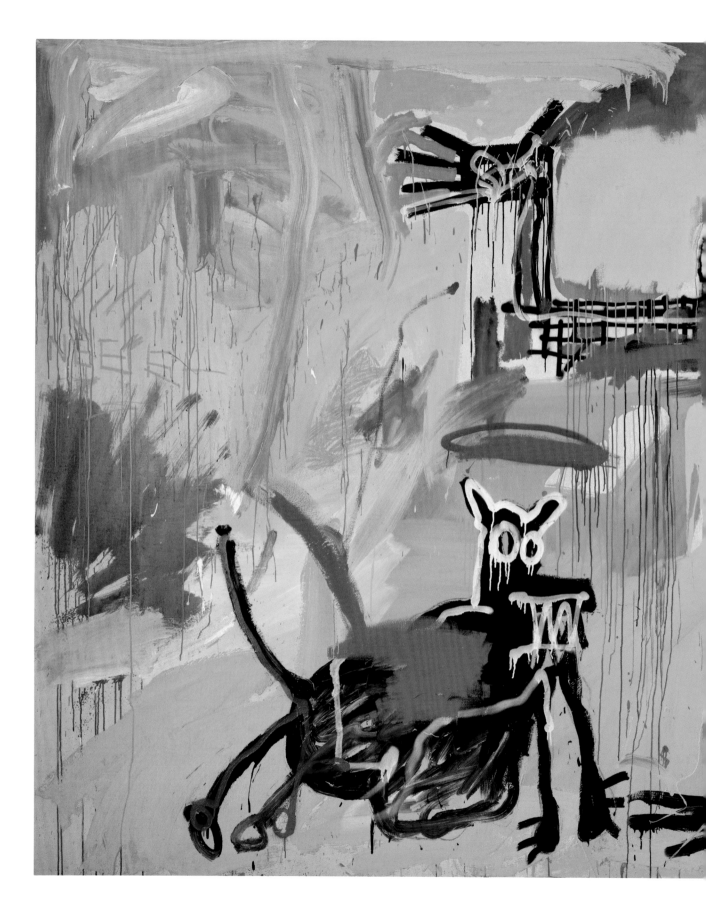

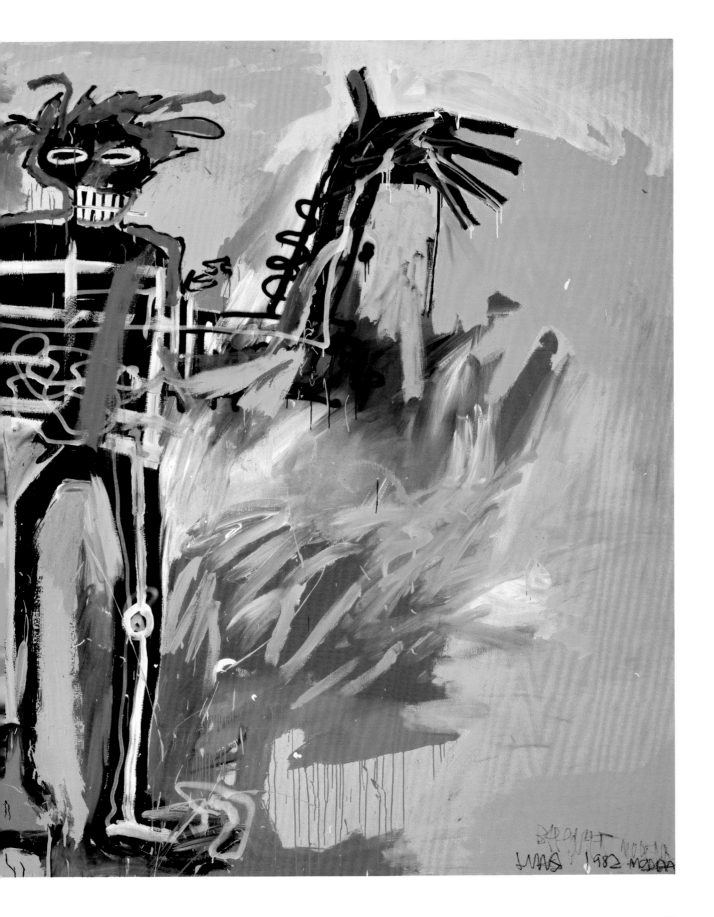

Untitled (Postcard), 1979
Ink, color pencil and collage on paper,
28 x 21.5 cm (11 x 8½ in.)

own work for a film titled *New York Beat* (ill. pp. 9 and 94), in which he played the leading role. The film was eventually released in the year 2000, under the title *Downtown 81.*

Basquiat broke with his friend Diaz in 1978, after the latter concluded that the future star artist was selling the graffiti movement out to the very establishment he once reviled. In reality, Basquiat had already distanced himself from the graffiti movement, even when his first solo exhibition in Italy went under his old pseudonym of SAMO. His loss of interest in spraying bares his fine sense for the mechanisms of the art scene: first riding the wave of the graffiti movement, then distancing himself from it again when public interest subsided and when other strategies proved to be more effective. The way in which Basquiat brought his SAMO graffiti to the bastion of the white-dominated gallery scene in SoHo and the East Village showed that he was thinking of how best to make a name for himself.

Unlike most graffiti artists, he stopped tagging buildings and subway cars, preferring the context of galleries or even openings, and drawing media attention to himself. The way in which the art market used him and other "kids" shows what he tragically shared in common with other graffiti artists. These kids, like Basquiat, moved from spraying subway cars to the canvases of the galleries, from being ignored to being shuttled from opening to opening, only to be unceremoniously dropped as soon as interest died. Seen in this light, Basquiat's statement that he was tired of playing the wild man of the art scene and for that reason pulled out of the graffiti movement, would seem to reflect only part of the truth.

In 1978 Basquiat left home for good, and began living with various acquaintances, without a fixed address. He had already abandoned high school, without earning a diploma. One place he often stayed was at the loft of the British artist Stan Peskett on Canal Street. Peskett gave many parties, and Basquiat was introduced at one of these to Lee Quinones and Fred Brathwaite, as well as to the future members of his band Gray, including Michael Holman, Danny Rosen and Vincent Gallo (ill. p. 23 bottom). Together they formed the so-called "Baby

Untitled, 1981
Acrylic, oilstick, and metallic spray enamel on canvas, 172.5 x 261.5 cm (68 x 103 in.)

PAGE 21
Early Moses, 1982
Acrylic and oilstick on canvas,
198 x 141 cm (78 x 55½ in.)

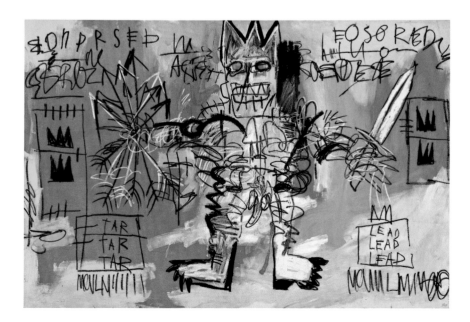

Untitled, 1981
Acrylic and oilstick on canvas,
127 x 302 cm (50 x 119 in.)

Crowd" at the Mudd Club, a trendy locale on White Street. This hotspot, cofounded by the curator Diego Cortez, established itself as a meeting spot for everyone who wanted to become famous, or who already was – from Lydia Lunch, David Byrne, Kathy Acker, and Brian Eno (who installed the sound system) to Klaus Nomi, Iggy Pop, David Bowie and Sid Vicious.

Despite the presence of these bright yet still-rising stars, who were doing everything imaginable to attract attention to themselves, Basquiat proved to be a light in his own right, noticed for his unusual dancing and his blond-dyed mohawk. He played in the club together with the band Gray, named in honor of the anatomy book his mother gave him in his youth. Like many bands of the late seventies, Gray cultivated a kind of Art Noise style, eschewing musical perfection and technical smoothness and reveling in a raw honesty that relied more on tone and sound than on melody. Basquiat played various instruments. He used to mistreat a guitar with a file, or lie on the ground and recite poems or passages from *Gray's Anatomy*. After only a few performances the band broke up, prompting Vincent Gallo to bitterly remark that it was Jean's fault. Yet only a few months later he was a star artist and millionaire, Gallo added, concluding that it was sometimes an advantage to be black.

Basquiat's friends included Klaus Nomi from Germany, one of the most colorful stars of the German New Wave, and also one of the earliest celebrity victims of AIDS. Basquiat was also, briefly, friends with Madonna and with Eszter Balint, who achieved a degree of fame through her role in Jim Jarmusch's 1984 cult film, *Stranger than Paradise*.

An important turning point came with Basquiat's first contact with Andy Warhol. Basquiat approached the "man from the Factory" after seeing him in a restaurant on Prince Street, where Warhol was dining with Henry Geldzahler, the curator for contemporary art at the Metropolitan Museum and later cultural minister to Mayor Ed Koch. Basquiat, at this point, was earning a little money by selling collage postcards and T-shirts painted by hand (ill. p. 20 top). He entered the restaurant, armed with a handful of postcards, and offered these to Warhol and Geldzahler to buy. As Warhol bought a card, Geldzahler waved Basquiat off. Three years later, Geldzahler, who in the early 1960s was one of the few

proponents of Pop art, used the help of Diego Cortez to contact the young artists Julian Schnabel and Francesco Clemente, and also became a prominent supporter of Basquiat, who eventually painted his portrait (ill. p. 23 top).

Following his break with Al Diaz and the decision to distance himself from graffiti, Basquiat documented the change by spray-painting the words "SAMO is dead" all over SoHo. Keith Haring, who first met Basquiat in the fall of 1979, held a requiem and delivered a eulogy for SAMO at Club 57, the uptown rival of the Mudd Club and showplace for Haring's famous "Blue Night Shows." After leaving the graffiti scene, Basquiat participated in his first large group exhibition, the "Times Square Show," which was held in June and July of 1980 in a vacant building at 41st Street and Seventh Avenue, in the heart of the seedy porno district. The show was organized by two groups, Collaborative Projects Incorporated (Colab) and Fashion Moda. Fashion Moda was an alternative gallery in the South Bronx, mostly dealing with graffiti art, while Colab was a group of artists who rallied around the concept of being against the contemporary art market.

Diego Cortez was a central player in the Colab group. Cortez's real name was James Curtis; the Spanish adaptation of his name was meant as a way of garnering his political and social aspirations. Trained as a filmmaker at the University of Chicago, and friendly with artists such as Nam June Paik, Vito Acconci and Dennis Oppenheim, Cortez came to New York in 1973 and engaged himself with the art-in-public-spaces movement. After meeting Basquiat at the Mudd Club, Cortez encouraged him to paint, and bought as many of his drawings and paintings as he could. Frustrated and seeking acceptance, Cortez hoped to make a name for himself as a curator and developed himself into a kind of broker for Basquiat.

The "Times Square Show" was held on four floors. In this menagerie of art and kitsch, Basquiat was allotted just one wall. The show was generally well received.

Portrait of Henry Geldzahler, c. 1981
Pencil, oil and paper collage on wood,
60.5 x 25.5 cm (23¾ x 10 in.)

Henry Geldzahler, curator for contemporary art at the Metropolitan Museum and thus one of the most influential people in the New York art scene. After initial rejection, he became one of Jean-Michel Basquiat's most enthusiastic promoters.

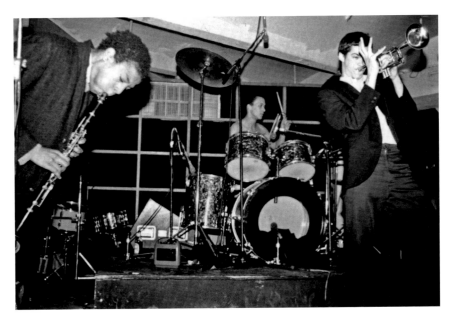

Gray at Hurrah's, New York 1979
From left to right: Jean-Michel Basquiat, Michael Holman, Shannon Dawson.
Photo Nicholas Taylor

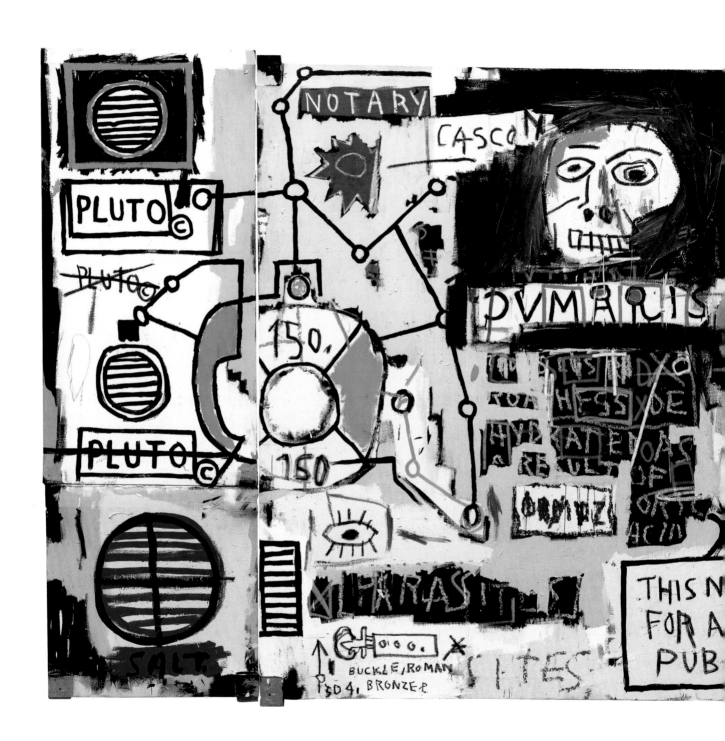

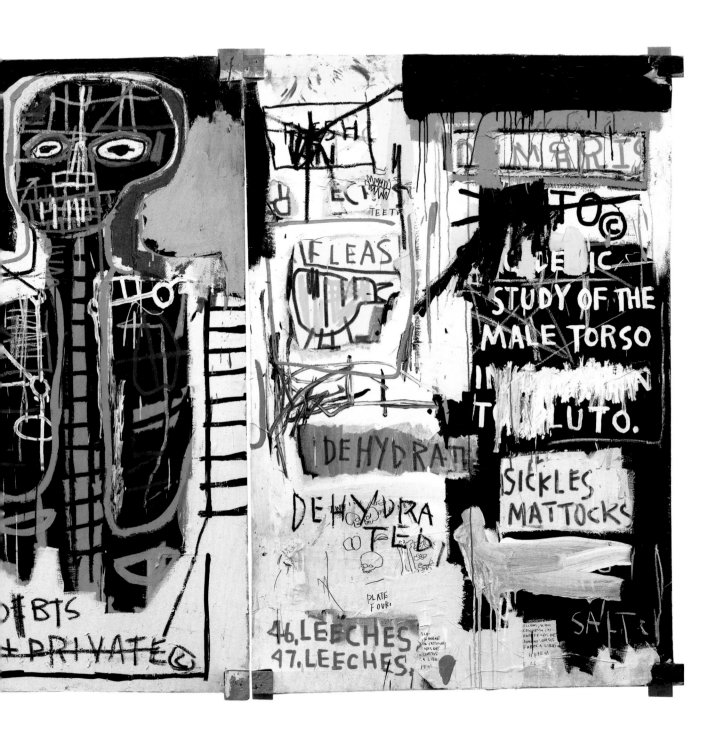

Notary, 1983
Acrylic, oilstick, and paper collage
on canvas mounted on wooden supports,
triptych: 180.5 x 401.5 cm (71 x 158 in.)

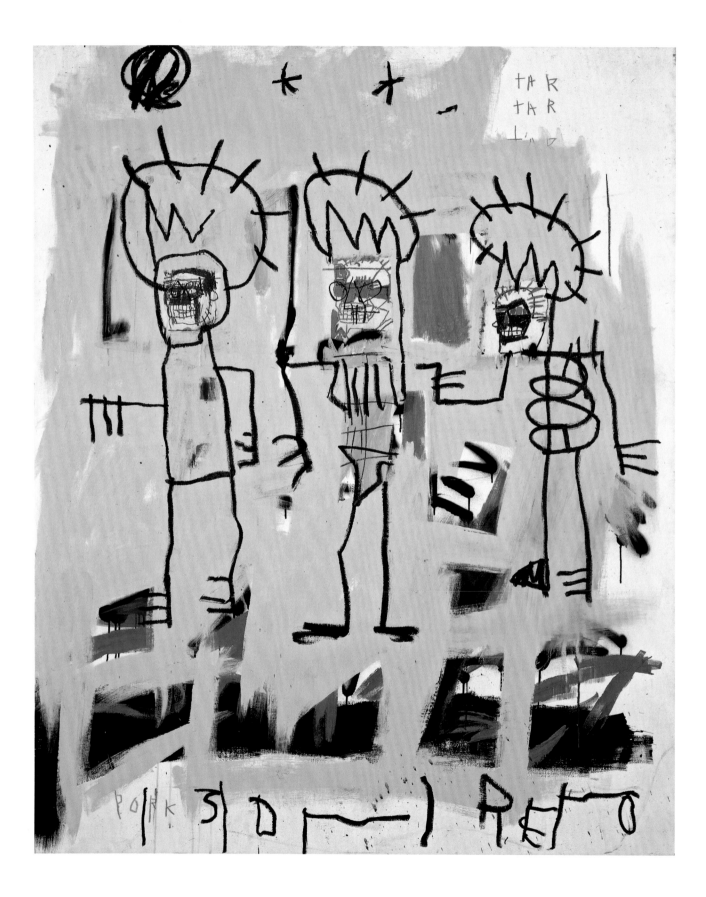

"Famous Negro Athletes #47"
On the Way to Stardom

Thus Basquiat made his entry into the world of art, as part of the "Times Square Show" in 1980, while still under the pseudonym of SAMO. Continuing his effort to promote himself as a curator, Diego Cortez subsequently organized the "New York/New Wave" show at the already legendary P.S.1, a former school turned art venue in Long Island City, Queens. Cortez managed to unite the entire New York downtown scene for this show, bringing together more than 1,600 works by 119 artists in a wild mixture that documented the crossover between the art and music scenes – a conjunction that Cortez dubbed "Neo-Pop." Chris Stein from Blondie, Alan Vega from Suicide and David Byrne of the Talking Heads appeared together with graffiti artists such as Lee Quinones, Rammellzee, Futura 2000 and Daze.

Basquiat was able to exhibit 15 works, many of which brought to mind children's drawings: cars, airplanes, schematic drawings of heads and skeletal sketches of figures, usually combined with letters that onomatopoeically imitated cries of exclamation or the wail of sirens. Here, Basquiat used a variety of formats and materials. His smaller works on paper were around 60 x 40 cm (23½ x 15¾ in.), while his paintings with acrylic and chalk on canvas were almost square, having a size of 160 x 170 cm (63 x 67 in.).

The Basquiat works at the "New York/New Wave" exhibition surprised in their aloofness and graphic sparseness: *Airplanes* (ill. p. 27) shows seven airplanes in a way not unlike children's drawings. (Basquiat once said that he respected the drawings of children much more than the works of "real" artists.) The paper is partly framed by lines, and partly divided into yellow fields of differing sizes. Despite its simplicity, its childlike rendering of the motif, and the apparent randomness of the lines and the scratchiness of the letters, a sophisticated economy of picture-building elements can be discerned, with a confident hand structuring the surface of the work and securely holding its tension. In a similar way, the work *AO AO* (ill. p. 28 top) displays frontally depicted figures as mere contours, a motif that later returns in monumental format.

Airplanes, 1981
Mixed technique on paper,
60.7 x 45.5 cm (24 x 18 in.)

Untitled (Three Kings), 1981
Acrylic, oilstick, and paper collage
on canvas, 170 x 139.5 cm (67 x 55 in.)

AO AO, 1981
Mixed technique on paper,
60.7 x 45.5 cm (24 x 18 in.)

AO AO shows the combination of words and
images typical of Basquiat's entire oeuvre, and
is characteristic of the early works, in which
abbreviated, child-like signs address the issues
of urban life.

A typical work for the period of the exhibition is *Cadillac Moon* (ill. p. 17),
a piece which helped him to his breakthrough. Once again, Basquiat demar-
cates the different areas of the picture, with lines acting as frames. On the right
is a row of television screens, top to bottom, each of which shows the outline of
a head viewed from the front. Some of the heads are painted over, while other
zones are repeatedly covered with the letter A in gestured brushstrokes. On the
left side, a pair of oddly-sized quadratic fields frame depictions of automobiles.
The one at the top appears to be moving along normally, and the circles above
it might refer either to the moon of the title, or to the combination of the letters
A and O, which are repeatedly found in Basquiat's early drawings. The car
in the lower field hangs on chains, being lifted on its chassis. The narrow un-
framed strip at the bottom of the work displays the word SAMO and a copy-
right symbol, the word AARON, the signature of Jean-Michel Basquiat and the
date of 1981.

Symbolically, the SAMO characters are crossed out. Although Basquiat
exhibited under this name, the change in image of the graffiti sprayer to a new
identity as the artist Basquiat seemed complete – now so proud of his artistic
inventions that he even sealed them with a copyright. AARON refers to a hero
of Basquiat, African American baseball player and all-time home-run king
Hank Aaron (born in 1934). Despite his talents, Aaron was forced to begin his
career in the Negro Leagues, before these were finally integrated into the ma-
jors in the 1950s. When playing in the southern states during spring training
the racial segregation laws in effect until the mid-1960s prohibited him from
sleeping in the same hotels as his teammates. As he carried his teams to count-
less victories and a championship on the strength of his hitting, and thrilled the
whole country with his many batting records, Aaron still had to endure insults
and abuse from fans.

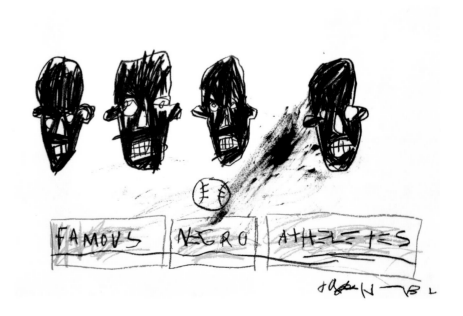

Famous Negro Athletes, 1981
Oilstick on paper, 71 x 89 cm (28 x 35 in.)

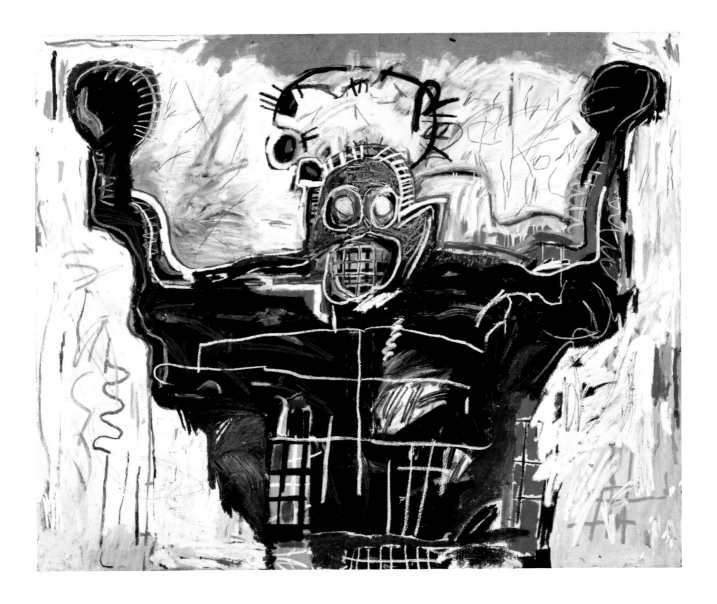

Aaron belonged to a long list of African American sports heroes which included his fellow baseball player, Jackie Robinson (1919–1972), the first black man to actually break the racial barrier into the Major Leagues. Basquiat honored them both with drawings in which he combined their names with a crown. He also used the script "Aaron" together with his trademark copyright symbol. Again and again, Basquiat's works are listed with names representing his revered idols. From the area of sports, he mainly iconized baseball players and boxers (ill. pp. 30 and 31). One drawing, from 1982, lists the names Muhammad Ali, Joe Frazier, Sugar Ray Robinson and Joe Louis. Sugar Ray Robinson (1921–1989) was one of the most celebrated figures in boxing between 1940 and 1965; his lifestyle influenced Basquiat considerably. Sugar Ray was notorious for his excesses at the Cotton Club in Harlem. On his trips he was accompanied by an entourage of women of all colors, and he had very exclusive tastes in clothing and spent money freely, quite like Basquiat. Basquiat's homage to this black fighter shows, in a way similar to those works honoring Hank Aaron and Jackie Robinson, the script of the boxer's name and the halo of a crown, though the work has a more disquieting aura with its wholly black background and skull-like depiction

Untitled, 1982
Acrylic and oilstick on linen,
193 x 239 cm (76 x 94 in.)

of the face. All of the gloominess and frustration generated by the repression of a white-dominated society, against which the boxer understandably used his arrogant and wasteful behavior as a bulwark, is contained in this simple work (ill. p. 32 top).

A more direct statement is delivered by *St. Joe Louis Surrounded by Snakes*, from 1982 (ill. p. 30). Like the works on paper from 1981, this piece employs a painted frame and inscription. In the middle of the piece sits a halo-crowned boxer, apparently resting during a pause in the ring; behind him are the faces of his trainer and advisor, whose financial greed would ruin the fighter. Joe Louis (1914–1981) became famous as he triumphed over the German boxer Max Schmeling at New York's Yankee Stadium in 1938. *Jesse,* from 1983 (ill. p. 35), is stylistically very different from the previously mentioned works. It names diverse elements such as kryptonite, the fictional stuff that neutralizes Superman's power, and derives mainly from a 1940 cartoon called *Popeye Versus the Nazis.* Above the swastika of the Nazis is the name Jesse Owens, together with the text

St. Joe Louis Surrounded by Snakes, 1982
Acrylic, oilstick, and paper collage on canvas, 101.5 x 101.5 cm (40 x 40 in.)

Boxers like Joe Louis, athletes like Jesse Owens, and musicians like Charlie Parker and Miles Davis constantly recur in Basquiat's cosmos of black heroes and martyrs.

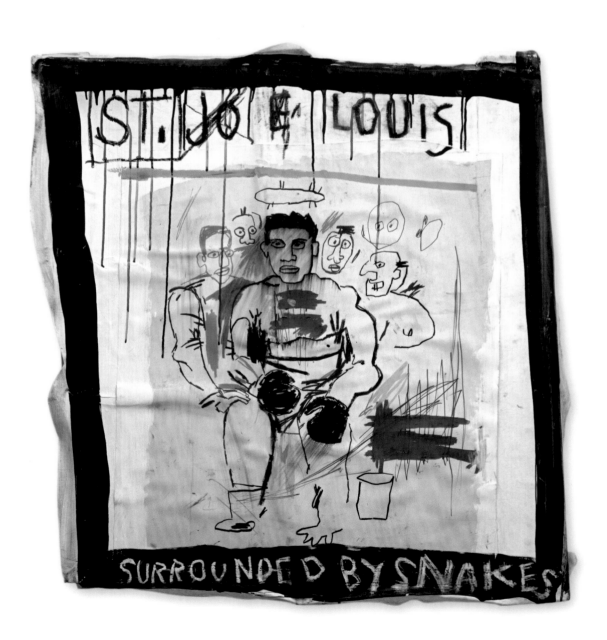

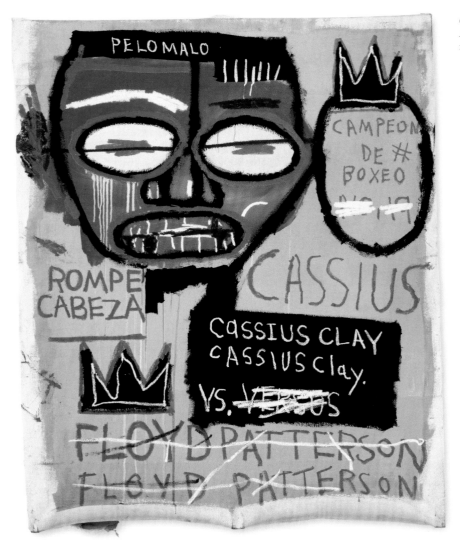

Cassius Clay, 1982
Acrylic and oilstick on canvas,
122 x 101.5 cm (48 x 40 in.)

"A Place for Negroes" and "Coloured People"; below the Star of David is "Negro Athlete," and beside the face of Owens, "Famous Negro Athletes #47." The works *Dark Horse Race – Jesse Owens* (1983) and *Big Snow* (1984) again relate to the sprinter Owens, who won four gold medals at the Nazi-showcased 1936 Olympic Games in Berlin.

Besides sportsmen, Basquiat also honored black musicians, especially Charlie Parker (1920–1955) and Miles Davis (1926–1991), a reverence proved distinctively in the works *Discography I* (ill. p. 34) and *Discography II,* both from 1983. The artist continued to dedicate works to the theme of jazz until the day he died. Basquiat in particular honored Charlie Parker, the seminal bebop saxophonist and composer often featured in his oeuvre. Beginning in 1941, Parker, together with Dizzy Gillespie, recorded music which set off a new revolution in jazz with its freedom of improvisation, introduction of scales and rapid tempo. Parker has a place as one of the most important rejuvenating forces in the history of jazz. Significantly, he never received formal training in music. Constantly afflicted with drug and alcohol problems, he suffered a nervous breakdown in 1946. Following several attempts at suicide, he died on April 2, 1955, tortured by mental and physical conditions.

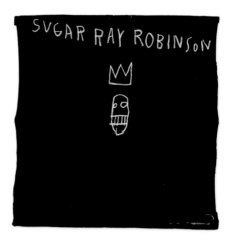

Untitled (Sugar Ray Robinson), 1982
Acrylic and oilstick on canvas,
106.5 x 106.5 cm (42 x 42 in.)

Charles the First from 1981 (ill. p. 33) contains various references to the life of the musician. The triptych displays many crowns, the most apparent of which is associated with the name of the Nordic god Thor. The many appearances of an "S" symbolized the comic-book hero Superman. While on the left side the nimbus is titled with the word "halos," in the center of the work it appears as a repeatedly contoured oval under the name of Parker's daughter, Pree, accompanied by the dates of her birth and death as well as a cemetery cross. The word "Cherokee" refers not only to the famous composition by Parker but also to the Indian tribe, among the original inhabitants of America. A more subtle epitaph is rendered in the work *CPRKR* from 1982. Like SAMO, CPRKR is an acronym. Underneath this underlined script, which acts as a title for the picture, there is the ubiquitous crown and the name of the hotel in which Parker died, together with the date of his death and a cross. The footnote at the bottom edge of the painting refers back to the aforementioned painting of 1981.

When Basquiat writes, in the lower region of the painting *Charles the First,* "Most young kings get thier head cut off," it is symptomatic of his choice of heroes. They are invariably martyrs, victims either of society's oppression or of their own restless or selfish lifestyles. It is poignant that Basquiat once said he would like to live like James Dean – who sped recklessly to his death at 24 in a car crash – or that he idolized Janis Joplin and Jimi Hendrix, the two groundbreaking rock musicians who died in 1970, both at the age of 27, both from overdoses of multiple drugs. Could the parallels to Basquiat's own life be more striking?

Red Kings, 1981
Acrylic on glass and wood,
81 x 93.5 cm (32 x 36¾ in.)

PAGE 33
Charles the First, 1982
Acrylic and oilstick on canvas, triptych:
198 x 158 cm (78 x 62 in.)

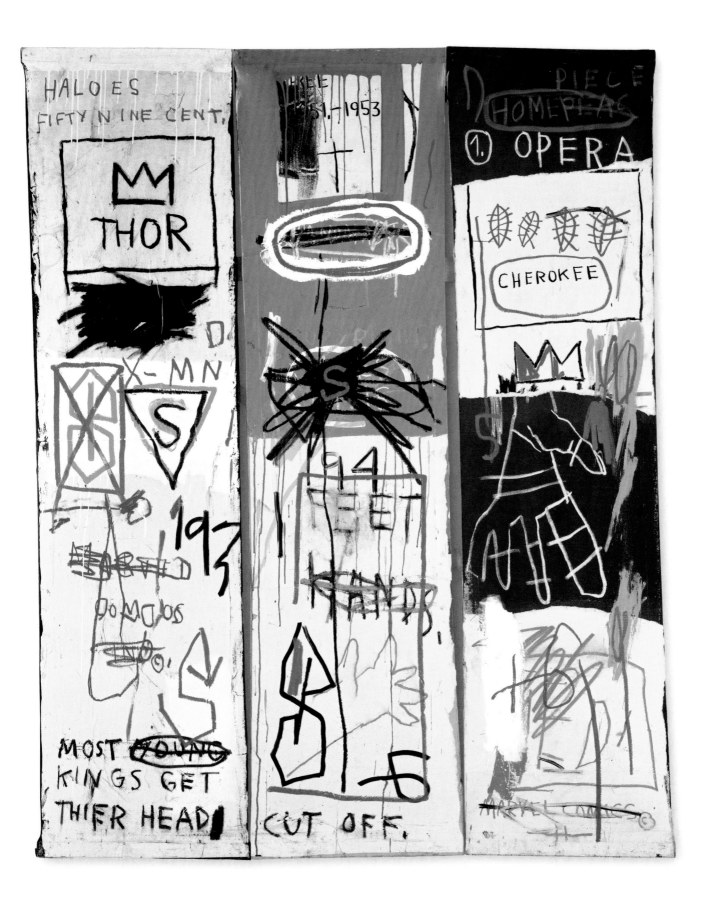

33

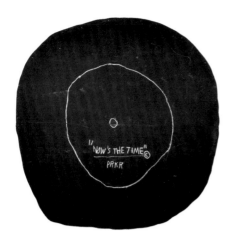

Now's the Time, 1985
Acrylic and oilstick on wood,
diameter: 235 cm (92½ in.)

The show at P.S.1 marked Basquiat's breakthrough. The director of P.S.1 herself, Alanna Heiss, otherwise noted for her critical stance to Cortez's efforts as curator, was very impressed by Basquiat's work. Yet it was thanks to the tireless efforts of Cortez that Basquiat's work attracted the interest of both artists like Sandro Chia and curators like Geldzahler. Chia wanted to purchase a picture, and Geldzahler, who previously had so rudely dismissed the young Basquiat, asked Cortez to help him make the artist's acquaintance. He bought a painted refrigerator, together with several other works. Objects such as painted refrigerator doors (ill. p. 37), painted boards, stools, tables, and so on are repeatedly found in Basquiat's work. He was also in the habit of painting everything he found appropriate or available in apartments where he was a guest. This led invariably to conflicts, ending in many cases with Basquiat being required to search for new accommodations, after he had completely painted and redesigned an acquaintance's apartment. Through Sandro Chia, Cortez encouraged the Italian gallery owner Emilio Mazzoli to take an interest in Basquiat. Mazzoli, who specialized in supporting artists of the Transavantgarde movement, joined Bruno Bischofberger in visiting both the P.S.1 exhibition and the loft on 36th Street where Basquiat was now lodging. Mazzoli not only bought works costing a total of around 10,000 dollars, he also invited Basquiat to put on a one-man exhibition in Modena, which the artist conducted in May

Discography I, 1983
Acrylic and oilstick on canvas,
167.5 x 152.5 cm (66 x 60 in.)

Like *Discography I*, many of Basquiat's works consist entirely of names and word lists. Basquiat termed these his "Facts." In their conceptual radicalism, these works prevent a simple classification of Basquiat as Neo-Expressionist.

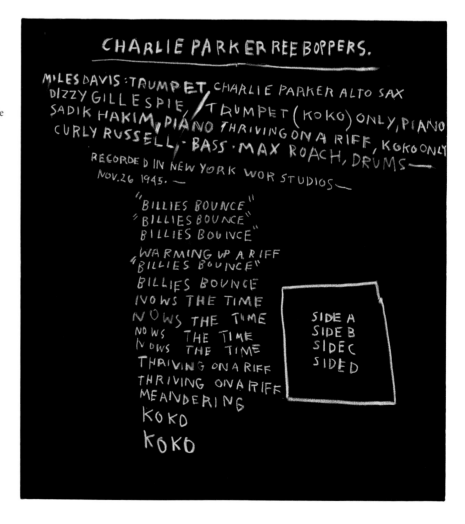

PAGE 35
Jesse, 1983
Acrylic, oilstick, graphite, and paper collage on canvas mounted on wooden supports,
216 x 180.5 cm (85 x 71 in.)

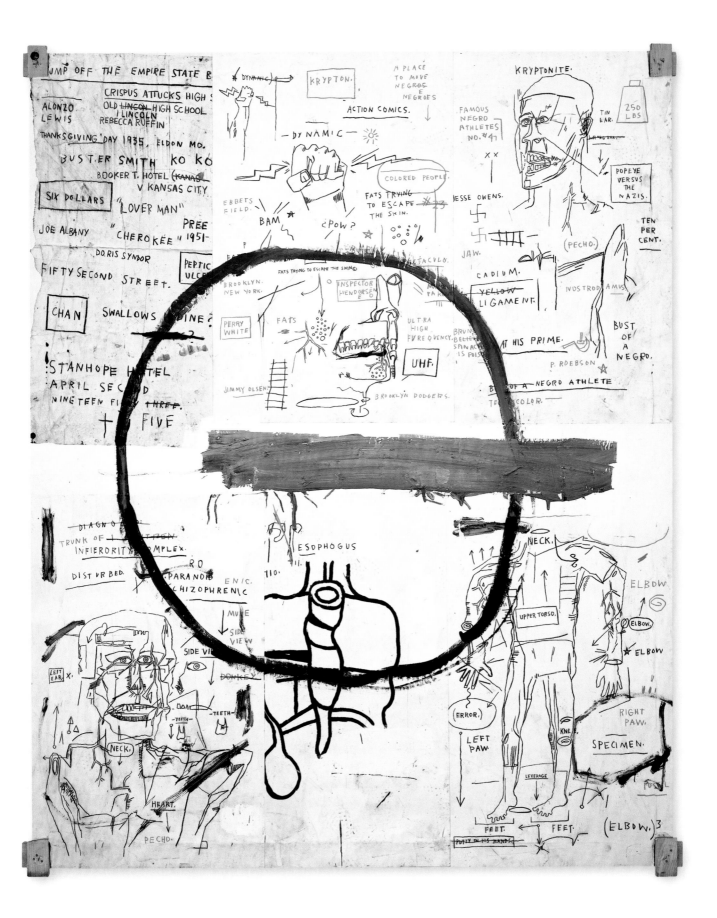

35

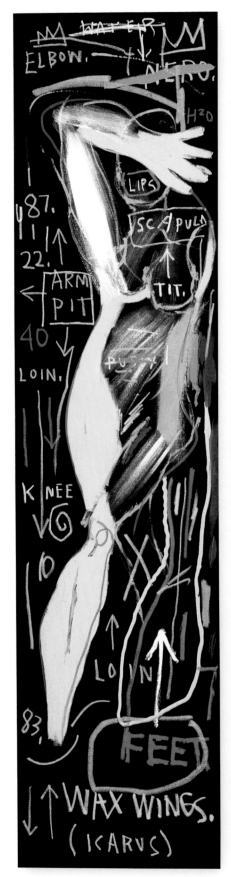

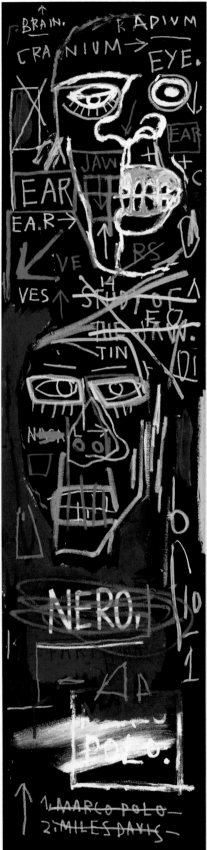

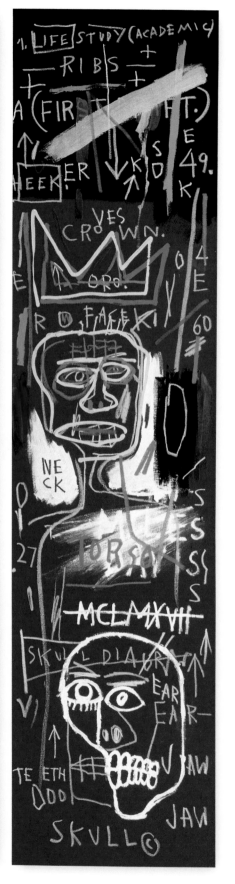

of the same year, still under the pseudonym SAMO. Meanwhile, Bischofberger bought many paintings and drawings from Cortez.

As Basquiat's first professional dealer, Annina Nosei deserves a special mention. Her background included contact with a notably intellectual group of art collectors, to whom she introduced the Italian style of Transavantgarde and the German movement of the Young Wild Ones (Die Jungen Wilden); for this reason, it was not difficult for her to promote Basquiat as simply the youngest in a phalanx of Neo-Expressionists. She offered the artist, who was permanently penniless and homeless, the use of the basement of her gallery as a studio, and cut a deal with him to use the revenues of any works she sold against what rent money he might owe. This unusual arrangement led to absurd situations. Nosei sold works by Basquiat to visiting collectors, regardless of whether they were considered completed by the artist or not.

The career of the graffiti artist turned insider star, whose paintings now brought prices between 5,000 and 10,000 dollars, moved so fast, in a way that Basquiat appeared neither able to control or comprehend. Still, he evidently had an intuitive sense of what was most advantageous for him in the short term. He realized he could maintain this favorable situation while letting other, older connections drop if need be. Diego Cortez discovered on his return from Modena that Basquiat had entered a working relationship with Nosei, who demanded that he, Cortez, relinquish all the artist's works in his possession. Basquiat no longer felt the slightest obligation to his former promoter, who admittedly was not exactly unselfish himself. Cortez thereafter refused to sell to Nosei, doing business with Bruno Bischofberger instead.

In October 1981, Nosei held a group exhibition in her gallery titled "Public Address," in which Keith Haring, Jenny Holzer and Barbara Kruger were featured, among others. The opening gathered the former combatants of the graffiti scene together with the chic clique of the downtown art scene. Yet Basquiat did not seem at all fazed by his rapid rise from the graffiti underground into highbrow society. During the opening he kept his Walkman on and barely took notice of the guests.

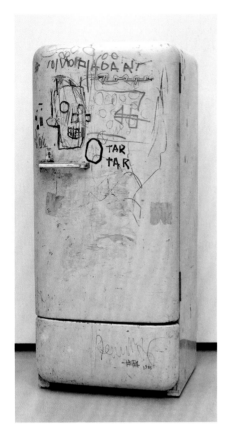

Untitled (Refrigerator), 1981
Acrylic, marker, and collage on refrigerator,
140 x 63.5 x 57 cm (55 x 25 x 22½ in.)

Basquiat often painted on the surfaces of found objects like doors, refrigerators, stools and tables, at times running into serious problems with his hosts when he would completely paint over their furniture without asking.

PAGES 38/39
Philistines, 1982
Acrylic and oilstick on canvas,
183 x 312.5 cm (72 x 123 in.)

Untitled, 1983
Acrylic and oilstick on canvas, triptych:
244 x 183 cm (96 x 72 in.)

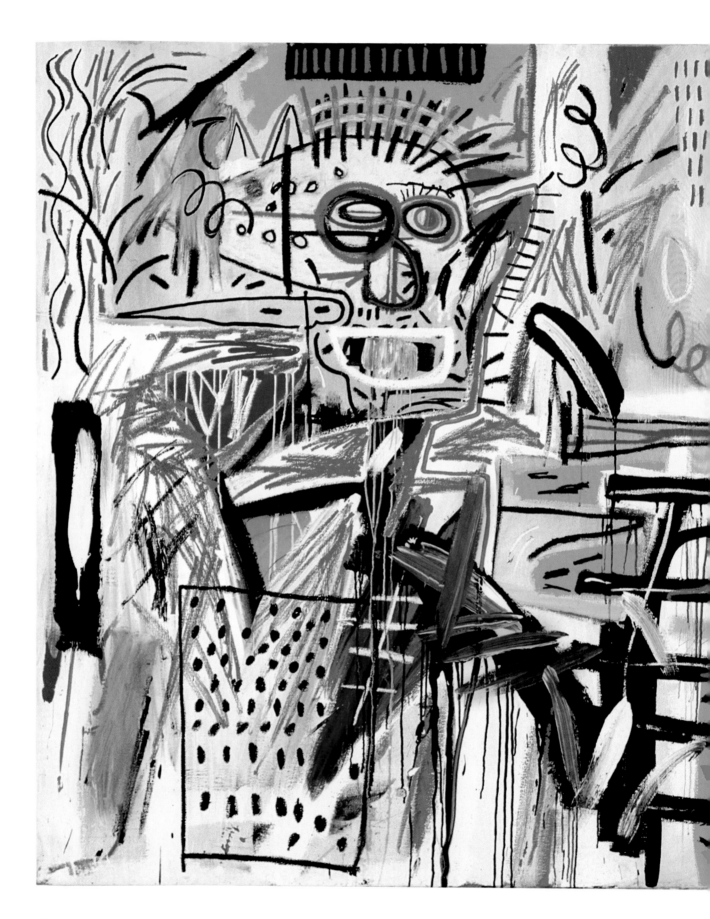

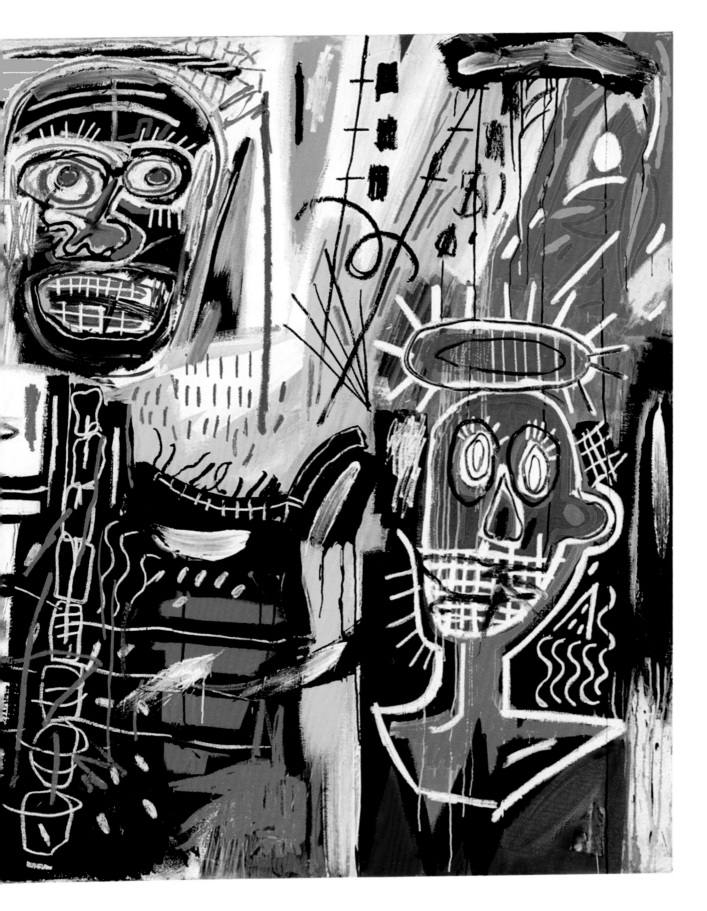

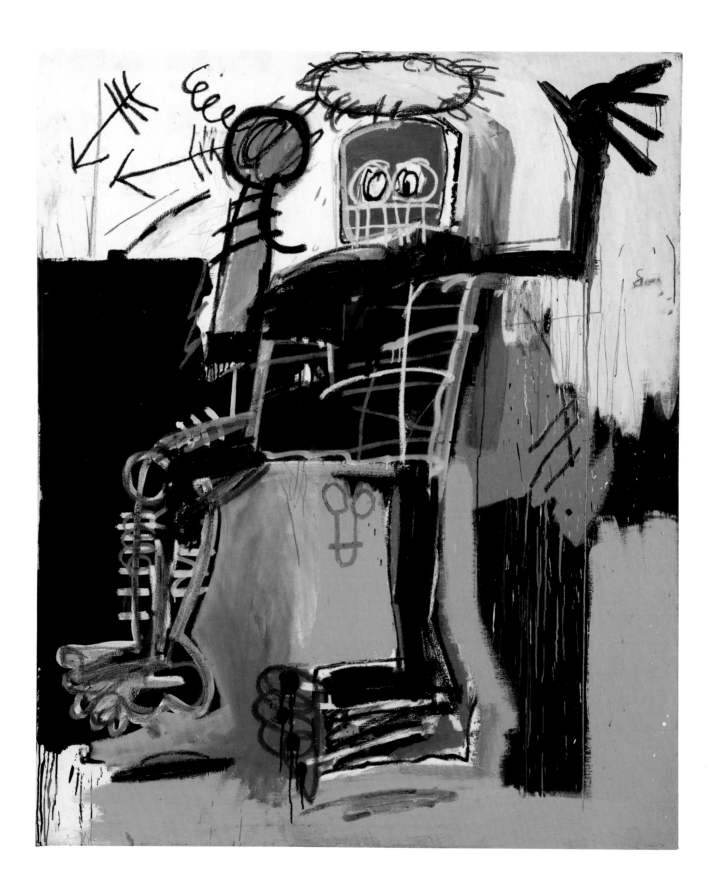

"Kings, Heroes and the Street"
Basquiat's Themes

Soon after the "Public Address" show, Basquiat's fame in the art world was boosted by art critic René Ricard's article "The Radiant Child," published in the December 1981 issue of *Artforum*. An acquaintance of Andy Warhol, Ricard had actually portrayed Warhol in a 1966 film, *The Andy Warhol Story,* but he later turned to written criticism with the self-appointed mission of reviving an art world that he believed was moribund. Ricard placed Basquiat's work in a larger tradition of art history, drawing parallels with Cy Twombly and Jean Dubuffet.

In fact these two artists were consistently associated with Basquiat. Cy Twombly (1928–2011) and Jean Dubuffet (1901–1985). To the mere question of whether he knew Dubuffet, we know that Basquiat reacted with an irritated "No!" We also know he kept a book of Twombly illustrations open next to his canvas while painting in Annina Nosei's cellar. Basquiat cites Twombly as an influence in a January 1983 interview with Henry Geldzahler. Basquiat's fusion of text with picture has often been attributed to Twombly, but the collage association of these two elements has been a standard of art dating back to Surrealism, and in itself is too vague to cement the claim of stylistic parallels between Basquiat and Twombly. Twombly's own work is clearly indebted to the pieces Dubuffet produced during his 1947/48 stay in the Sahara. Twombly's use of text represents both a simultaneous yearning for and rejection of meaning, constructing an associative openness, ephemerality and ambivalence that is clearly foreign to Basquiat. While Basquiat's work overflows with references and obscuranta just as much as Twombly's, these are not presented in an open structure accessible from all directions, but as a simultaneous dynamic among differing and in themselves hermetic statements.

Basquiat's style and expression, the sheer fierceness of his work, are far more removed from Twombly's ethereal, fine-nerved art than from the rude urban reality brought to canvas by the young Dubuffet. But Basquiat exceeds even Dubuffet in his depictions of the terrifying, the shattered, the unconnected, and in his demolition of and contempt for any kind of traditional visual unity – a quality that Dubuffet still upheld. For all the stylistic superficialities linking Basquiat to the artists whom he explicitly admired – like Picasso, to whom two Basquiat pictures are dedicated (*Agony of the Feet*, 1982, ill. p. 51, and a Picasso portrait of 1984) – or to the early Jackson Pollock, Basquiat's work during the 1981/82 period most clearly shows the influence of that earlier autodidact,

Warrior, 1982
Acrylic and oilstick on wood panel,
183 x 122 cm (72 x 48 in.)

Untitled, 1981
Acrylic, oilstick, and pencil on canvas,
183 x 152.5 cm (72 x 60 in.)

Dubuffet. Big city life, the main subject of Dubuffet's work in several cycles, is equally central to Basquiat's early paintings. Dubuffet's childlike and naive attitude to style and disinterest in central perspective and lighting, as seen in his *Vue de Paris – Le Petit Commerce* (1944), is just as evident in the Basquiat painting *Untitled (Blue Airplane)* of 1981 (ill. p. 43).

Dubuffet's works of 1945 and 1946 made a central motif of Paris street graffiti, a full 15 years before photographer Georges Brassaï published his essential documentary volume on graffiti in 1961 (with a foreword by Picasso). Dubuffet's paintings often made a subject of inscriptions on walls, graffiti tags and drawings scratched into wet concrete on the pavement, as in *Mur aux inscriptions* (1945) and *Decayed Wall at 34 rue Lhomond* (1945). By etching his figures into a pastose-painted background, Dubuffet transposed graffiti technique to the medium of canvas painting. He explicitly cited the anonymous street artists of the French metropolis as his "unartistic" models.

In Basquiat's case, his first canvases were, of course, the walls on which he sprayed as a young man. Wall surfaces, their textures scratched with messages of multiple provenance, later return to Basquiat's work as the content of paintings like another *Untitled* of 1981 (ill. p. 42). Both the content of this piece and its emergent techniques of heterogeneity and multiple layers as the defining visual elements will continue to evolve as the running themes of Basquiat's art until his death.

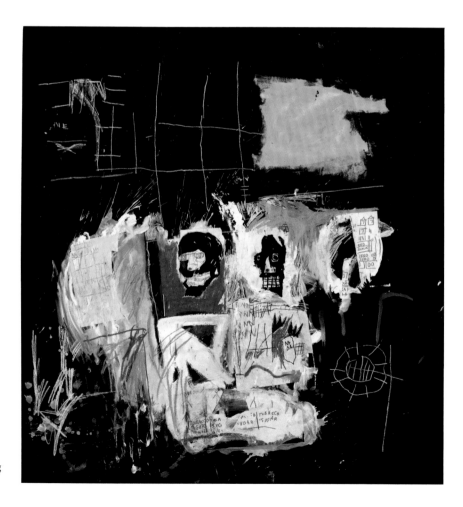

Untitled, 1981
Acrylic, oilstick, chalk, and paper collage on black paper, 150 x 141 cm (59 x 55½ in.)

Next to Picasso, Cy Twombly and Franz Kline, the French painter Jean Dubuffet's raw painting style decisively influenced Basquiat's art.

Untitled (Blue Airplane), 1981
Acrylic, oilstick, and spray paint on canvas,
218.5 x 264 cm (86 x 104 in.)

The works of the 1981/82 period are among the most vital in Basquiat's oeuvre. He created *Profit I* (ill. pp. 46/47) in March 1982, during his second stay in Modena, a time just as unpleasant for him as his first visit there in 1981 and his stay at Nosei's basement gallery. The dealer Mazzoli apparently put his artists under great pressure to produce. He provided canvases and painting materials to Basquiat in the hope of obtaining as many paintings for immediate sale as possible. *Profit I* captures that situation with overwhelming verve. Its impact derives from the contrast between the black background and the expressiveness of the half-figure filling the right half of the picture, whose raised arms grasp towards the viewer. A first glance suffices to show that this canvas was painted over several times. Before the application of the black layer, the whole canvas seems first to have been covered by a light-blue background with accents of yellow, which are still visible around the main figure. Basquiat then scratched his scribbles, arrows, letters and imitations of Roman numerals onto the black paint. The black streaks on the red shirt serve to lend form to the figure by following its contour, but are also gestural in nature, adding to the painting's overall furiousness. The head, mouth and eyes are rendered in thick white brushstrokes. The head is crowned by a yellow-glowing nimbus, recalling the crown of thorns, at least to

those observers who do not merely dismiss this clear evocation as "rays of light emanating from a halo."

While the connection to Basquiat's personal situation may guide us in interpreting *Profit I,* we would be wrong to reduce its statement solely to an autobiographical content. The protagonist of *Profit I* is typical of a Basquiat pathos that weaves together a number of parallel meanings. A male torso with upraised arms appears again in Basquiat's *Untitled (Saint;* 1982, ill. p. 48), who is also crowned with a nimbus. Christian themes are evident in *Crisis X* (1982), the adaptation of a crucifixion, and in *Untitled* (*Baptism;* 1982), where the right figure's raised arms bespeak not so much rage and protest as the open supplication of an orant – the motif of a praying figure common to early Christian art. But the figure of *Profit I* is most obviously repeated in *Untitled (Angel)* of 1982 (ill. p. 45). Even if *Profit I* is not meant as an explicitly religious statement, given that Basquiat's works often play on the iconography of Christian saints, *Profit I* stands out unmistakably as a personification of sacred exceptionalism. If the rays accentuating the main figure's nimbus are indeed meant to evoke the crown of thorns, then this same enraged hero is a martyr, a sacrifice like Christ.

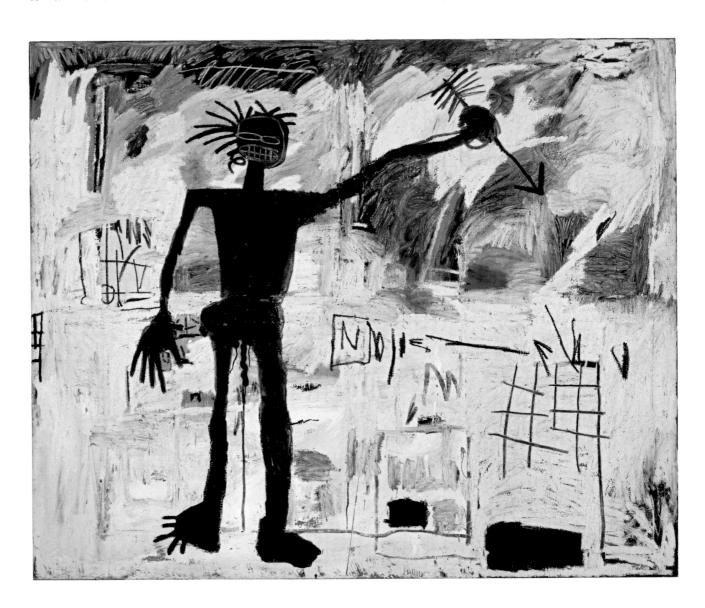

Self-Portrait, 1982
Acrylic and oilstick on linen,
193 x 239 cm (76 x 94 in.)

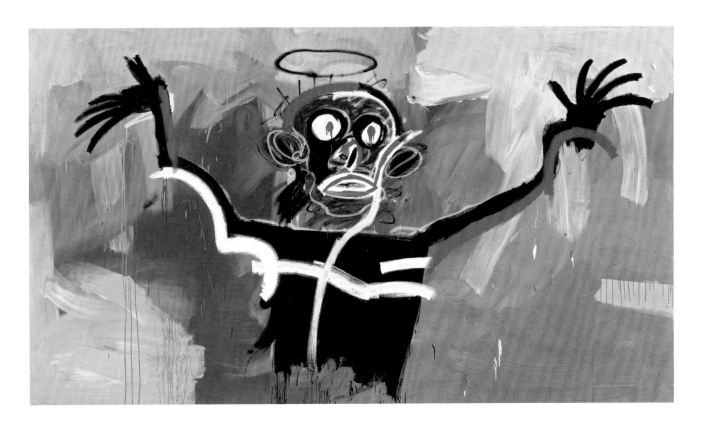

In Basquiat's situation, it is eminently plausible that this is meant as a reading of his role as an artist, all the more so when we consider the various African American heroes he honors: athletes and musicians whose lives suffered beneath the yoke of white oppression. The *Saint,* accompanied by a birdlike creature drawn in a child's hand, is not just an archetype meant to reconcile the kingdom of man with the animal kingdom; he is just as much a fighter, as his balled fist and swelling biceps make clear.

The self-portrait from 1982 (ill. p. 44) further establish Basquiat's association of sacral exceptionalism, martyrdom and heroism with the figure of the artist. The painting is an outstanding example of Basquiat's play with color. The entire image surface is dominated by areas of white, blue-gray and black. Only a triangular patch of red and a dark-yellow field behind the hand of the naked man lend contrasting hue. With its scratched-in figures and pastose application of paint, the background achieves the effect of a wall peeling with falling plaster. Done entirely in black, the figure of the artist stands out like a shadow, burned magically into the wall. His one identifying characteristic is a head full of dreadlocks, which Basquiat started to wear soon after he switched identities from SAMO to Jean-Michel Basquiat and chopped off the old blonde-dyed mohawk. A liquid – perhaps urine – flows from the figure's penis to the floor.

The upraised left arm holds an arrow pointing to the lower right corner, establishing the connection between the artist's self-portrait and the *Saint,* who holds a staff in his own upraised left. And the rays (crown of thorns) link the *Saint* to the second self-portrait. The canvas is collaged with chalk drawings on paper. The figure in the second self-portrait is not dense and solid as in the first, but outlined by a few spare lines that suggest a knee, ribs, arms. The face is a black circular area with nose, mouth and eyes drawn in white, while a halo floats above the head.

Untitled (Angel), 1982
Acrylic on canvas,
244 x 429 cm (96 x 169 in.)

PAGES 46/47
Profit I, 1982
Acrylic and spray paint on canvas,
220 x 400 cm (86½ x 157½ in.)

Profit I, with good reason one of Basquiat's best-known works. The use of hue and dark/light contrasts and the opposition between gesturally painted fields and expressive figures create an overall image of rage without parallel in the painting of the 1980s.

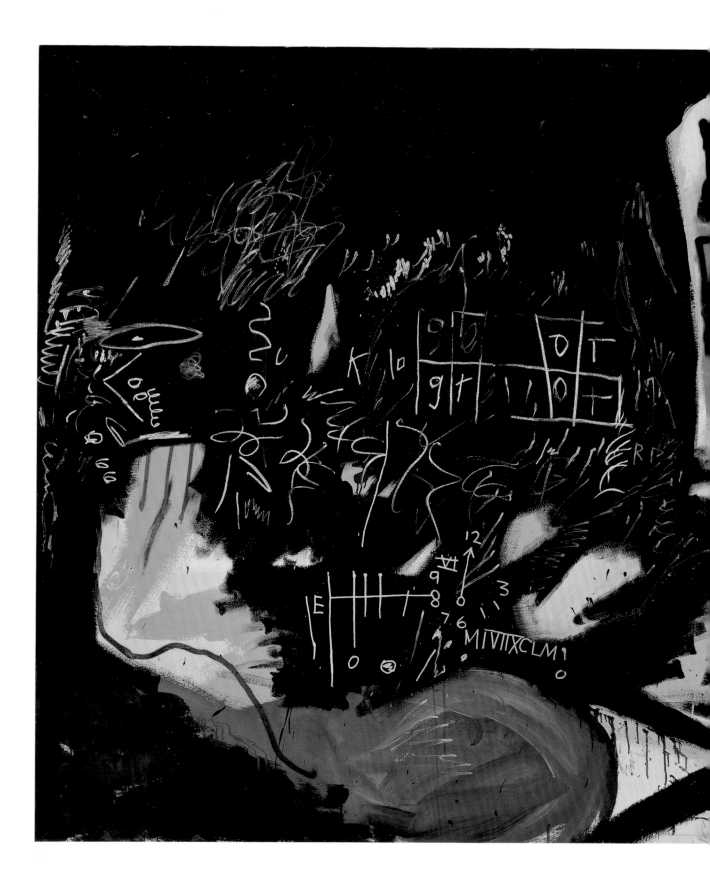

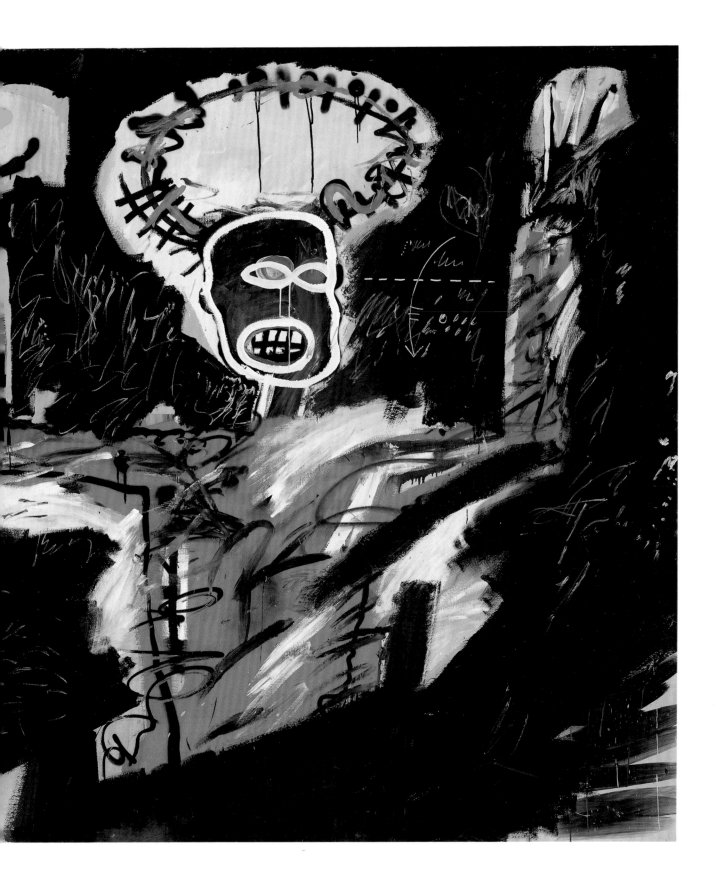

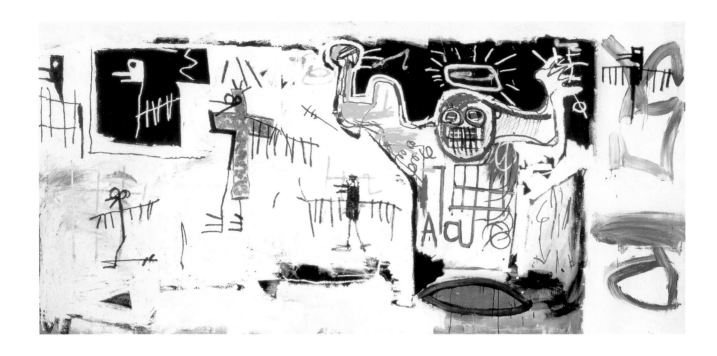

Untitled (Saint), 1982
Acrylic and oilstick on linen,
180.5 x 381 cm (71 x 150 in.)

Once again the artist is closely linked to the warrior-martyr in *Self-Portrait –
The King* (1981) and in another painting from the same year, of a man with a
nimbus walking towards the right, holding an arrow in his left hand, and repeat-
ing the balled-fist gesture of the boxer (*Untitled;* ill. p. 40). This warrior has all
the appurtenances of martial fearsomeness with which Kubin's personification
of war also stamped down on a ravaged earth.

Looking past his childlike means of depicting the big city to the actual image
of human beings in his work, Basquiat's is clearly an art of rage and rebellion.
But it always retains, if in reduced form, the cunning word games from his graf-
fiti phase – from the time of SAMO as the declared enemy of art. The crown and
the copyright symbol are the most obvious carryovers from the graffiti period to
the later paintings and drawings. The crowns bestowed on SAMO and the sports
heroes among others are meant as entirely straightforward, unironic honors to
the depicted person, in keeping with Basquiat's own statement that his themes
are "kings, heroes and the street." The SAMO tag, shortened to an S and com-
bined with the crown, lives on in many of the 1981 paintings, which are readily
identifiable by the contrast between painted backgrounds and drawn elements,
and by the choice of themes from big-city life. The *Untitled (Red Man)* of 1981
(ill. p. 49) shows the now-familiar figure with upraised arm, in this case neither
a hero nor a warrior, but more an echo of police tape outlining the former loca-
tion of an accident victim on the asphalt. A scratched-in airplane and several
cars suffice to indicate the urban setting. Colliding automobiles, possibly in
direct reference to Basquiat's accident at the age of seven, can be seen in another
Untitled of the same year, in that case combined with a quote from the children's
game known as "Skelly Court" (or in its European variant, "Heaven and Hell.")
The simple houses with Stags are meant as nostalgic recollections of the graffiti
phase, in which Basquiat had written his sentences on the houses themselves.

Far more ambiguous than the crown is the copyright sign, which in its direct
function touches upon ownership and the valuation thereof. Painted on the
walls of other people's buildings, it not only demonstrated SAMO's authorship

but generally questioned the idea of legality itself, like all sprayed tags turning anonymity into an open profession and claiming a formal legal protection for an activity that in reality remained illegal. Basquiat developed his play on the copyright sign in later paintings like *The Dutch Settlers* (1982) and *The Pilgrimage* (1982), adding to it a kind of notarial seal in a new turn on his sampling technique. The blue background layer of *The Pilgrimage,* mostly painted over by a layer of grayish white, serves equally well in representing water as it does the sky with an airplane above. An assortment of arrows and crowns, the stick-like birds already seen in *Saint,* a consciously clumsy copy of a medieval bishop on a horse, a black worker with a rake, the Batman logo, annotated drawings and text from an anatomic dictionary, the signaling of value through the use of the copyright sign, and the repeated, once half-erased addition of a notary's seal… on first impression, all this makes for an unconnected mishmash of different visual ideas and sources.

To his predilection for anatomic charts and love of children's drawing style, Basquiat adds an occasional reliance on comic-book sources like *Mad, Batman, Superman* and *Popeye.* In no way does his painting try to disguise the many inspirations drawn unadulterated from television and the popular visual media. That is exactly what makes it evocative of its era, an age shaped mainly by the mass media. *Untitled (Sheriff)* of 1981 also directly adopted the technique of a comic strip. From the left, a man in prison stripes, decorated with the crown and notarial seal, pokes a fork into the eye of a sheriff, recognizable by his pistol and star. The primal letters scrawling across the lower third of the picture vividly accompany the dramatic event, its brutality amplified by a spurt of blood from

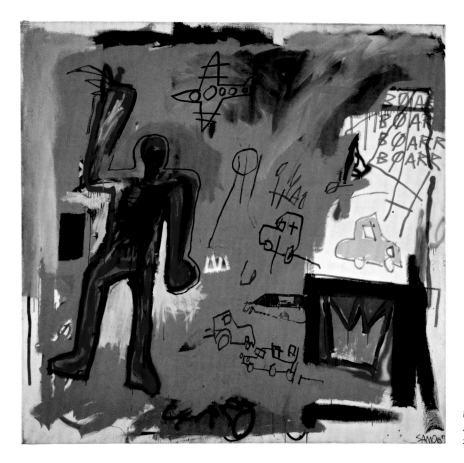

Untitled (Red Man), 1981
Acrylic, oilstick, and spray paint on canvas,
204.5 x 211 cm (80½ x 83 in.)

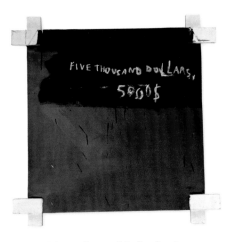

Untitled (Five Thousand Dollars), 1982
Acrylic and oilstick on canvas mounted on
wooden supports, 93.5 x 92.5 cm (36¾ x 36½ in.)

Basquiat's works often include direct references
to his position on the art market. An extreme
example is *Five Thousand Dollars,* in which the
price ostensibly demanded for the painting
makes up its only content.

the sheriff's eye. Agitated brushstrokes serve to generate an impression of speed
and drama-in-the-moment.

From 1983, the painting *Notary* (ill. pp. 24/25) takes the notarial seal as one
crux within a complicated arrangement, built through several layers of paint out
of elements of anatomical sketches, Greek myth and history. The center features
the half-figure of a man whose body appears, through the use of internal lines,
to have been skeletonized. The caption on the right edge, "Study of the Male
Torso," is obvious enough as a label. Repeated several times around the painting
is the word "Pluto," denoting the Graeco-Roman lord of the underworld and,
surely not by coincidence, the god of wealth. Various classical sources report
that the god Pluto was blind and therefore indiscriminate in his distribution
of life's riches, and his characteristic symbols included the horn of plenty. Also
repeated at several spots, in part painted over, are the words "dehydrated" and
"as a result of…", though the actual cause of dehydration has been redacted by
paint or is illegible. Pluto's role in this cosmos of meanings may be meant as the
indirect self-characterization of the artist himself, who was known for indis-
criminately sticking rolls of money into the pockets of beggars and homeless
people, and who evinced an incomprehensibly reckless generosity in financing
the travel costs of his friends whenever and wherever they accompanied him. As
the lord of the underworld, Pluto is traveling towards death, which in the paint-
ing is present as the threat of the skeletal form and in the naming of a specific
cause of death: dehydration. The additional specification of "parasites" and
"leeches" and the drawing of a flea give further clues as to the cause of this
dehydration: sucked dry by parasites.

The notary's seal is placed on a green background and in direct association
with the inscription below the main figure: "This note for all debts public +
private ©." This declaration turns the picture into a form of cash or certificate,
the legality of which is fixed by the seal. The painting can thus be read as a self-
portrait with legal clauses, or else as an encoded description of the situation in
which Basquiat saw himself: sucked dry, faced with the reality that whatever the
ideal value he wanted to convey in his work, it was still seen by his set primarily
as a product of financial value, drawing him into the expanding whirlpool of
uncontrollable circulation and accumulation of value.

With at least two other paintings, *Danny Rosen* and *Hollywood Africans in
Front of the Chinese Theater with Footprints of Movie Stars,* both from 1983, *Notary*
shares the presence of a curious word found in none of the world's dictionaries:
JUMARIS. This coining of Basquiat's is derived from a Greek inscription he
discovered in a painting photographed on page 88 of Burchard Brentjes' book
African Rock Art (New York, 1969; ill. p. 84 bottom). The photo shows St. George
with the Greek word φωπις. The drawing is by the anonymous artist of a nomadic
tribe in the eastern Sahara, the Blemyers, who at each campsite on their annual
trek drew figures on boulders as signs to other members of their families and
clans; graffiti in the original sense (sgraffito is derived from the Greek "graphein,"
meaning to etch, write or draw). In their art, the Blemyer tribe mixed elements of
African religions, Egyptian mythology and Christian iconography. We can
say with certainty that Basquiat's coining in Latin letters of the word JUMARIS
was not animated by the mere corruption of the Greek word's graphic form.
Rather, the hybrid identity of the Blemyer tribe, and their way of uniting frag-
ments of different cultural origins into their own unique synthetic language, must
have fascinated Basquiat as an early foreshadowing of his own artistic technique
of sampling, indeed of his own near-indescribable and multifaceted identity.

In other works, Basquiat raises aversion to the marketing of his own art into a form of symbolic brutality. One painting from 1982, *Untitled* (*Five Thousand Dollars*; ill. p. 50), consists of a canvas in two shades of brown, on which he wrote the intended sale value of the painting in words and numerals. The painting shows nothing other than the denomination of its own value. There is no added "artistic" value, there is no hint of a "meaning." In his inimitable way, Basquiat is here repeating the affirmative strategy of his idol, Warhol, in that he abandons any attempt to conceal the functioning of the capitalist art market by producing "content," instead reducing the whole process to its defining value of making money. The painting is nothing more than a price tag; a purchasable price tag.

Basquiat continues this ironic, sometimes bitter and sometimes humorous play on the art-market value of his paintings with other inscriptions, like "peso neto," "estimated value" and "200 yen." He does much with words for foods, chemical substances and metals. The S, which represents Superman whenever it appears within a triangular logo and otherwise stands for the old tag SAMO,

Agony of the Feet, 1982
Acrylic and oilstick on canvas,
183 x 213.5 cm (72 x 84 in.)

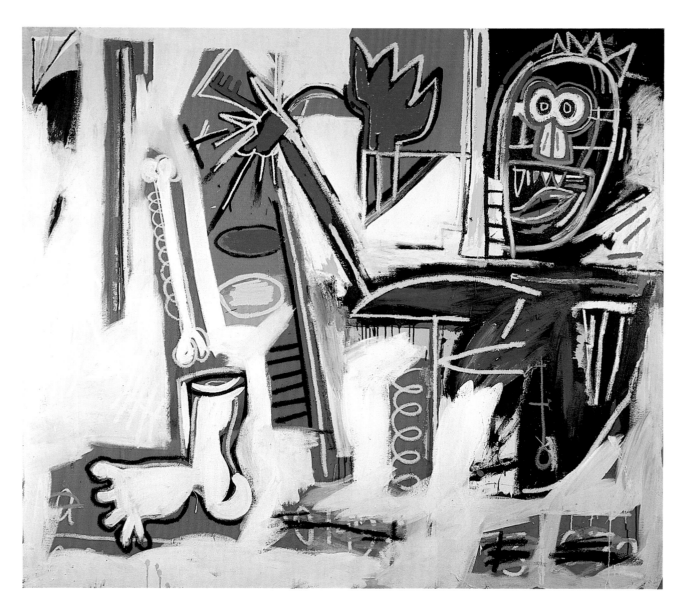

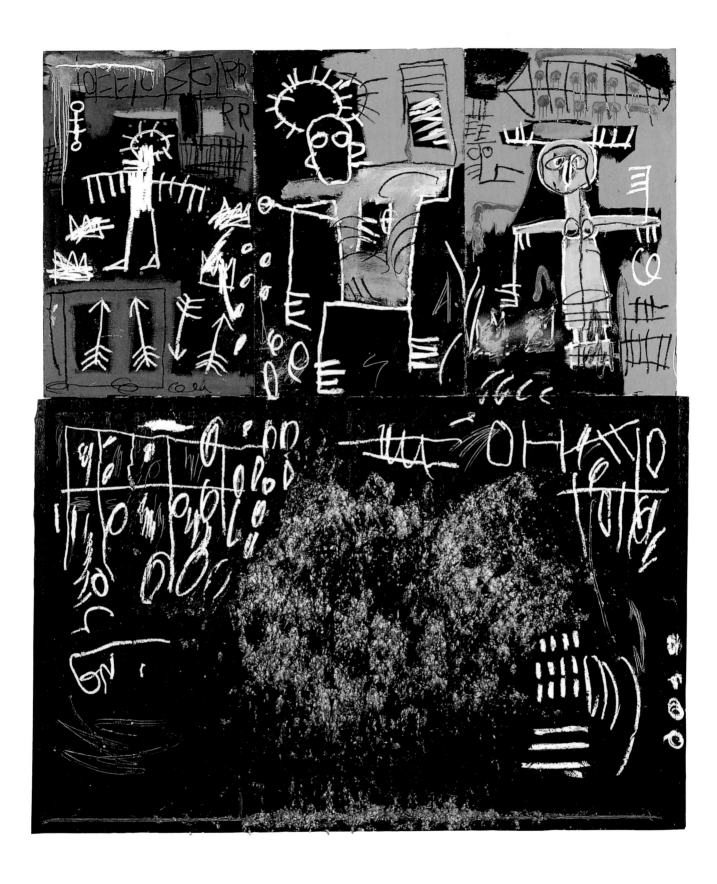

also stands in for "salt." A 1981 drawing shows nothing more than the word "Milk" emblazoned with a copyright sign. This drawing, also a kind of radical poesy, combines a staple food with the claim of control over its distribution and the consequent ability to draw a profit from it. The absurd notion that a food could be subject to copyright regulation touches on the problem of just resource distribution, an issue Basquiat also brings up when naming various other materials and metals. Over and over, his works feature words like "lead," "asbestos," "carbon" and "tar." Milk seems to be associated with the lyrics of a song that Basquiat often listened to, "Tell Me That I'm Dreaming," by Don Was, with the immortal line: "Man needs milk, so he owns a million cows."

From the year 1982, the painting *Dextrose* brings to bear much the same formal radicality as the earlier *Five Thousand Dollars*. Like many of Basquiat's paintings, it looks unfinished. This intentional effect posed a challenge to many observers of his work; some of his paintings were removed from his studio and sold before Basquiat considered them finished. His techniques of gradual collage and of repeatedly painting over the same surface stood in contradiction to the market demand that called on him constantly to raise his volume of artistic production, at times leading to a vulgar cash-and-carry business. *Dextrose* can be viewed simply, as a pure case of color-field painting. Once again, Basquiat has applied several layers of color on top of each other, gold dominant with a contrasting thick-stroked shock of black coming down from the top. Decorated with the signature three-pointed crown, the word "dextrose" has been written on the left, towards the center. The painting, which was owned for a time by Andy Warhol, is one of Basquiat's most minimal. It shows that the labeling of Basquiat as a Neo-Expressionist is only part of the story. Just at the point where visual elements of differing provenance are combined pistachio-like and in a highly mannered fashion, Basquiat achieves works of a complexity that can no longer be adequately understood simply in terms of a will to pure expression.

The now-familiar figure of the man angrily raising his arms to the heights returns again in another 1981/82 painting, *Asbestos* (ill. p. 53). Like "tar," asbestos is one of the most oft-repeated words in Basquiat's work. Like "carbon," tar is a direct treatment of the racial problem. Asked about his frequent use of "carbon," Basquiat shot back: "How black do you think I have to be?" The blackness of tar is similarly associated with Basquiat's skin color, but takes on a far more ominous meaning in a painting like *Untitled (Black Tar and Feathers)* from 1982 (ill. p. 52), in which it refers to the racist practice of tarring and feathering black men.

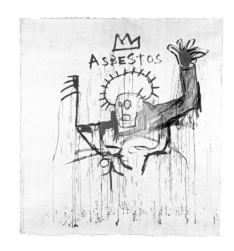

Asbestos, 1981/82
Acrylic on paper mounted on canvas,
282 x 272 cm (111 x 107 in.)

Untitled (Black Tar and Feathers), 1982
Acrylic, spray paint, oilstick, tar,
and feather on wood, polyptych:
275.5 x 233.5 cm (108½ x 92 in.)

PAGES 54/55
Famous Moon King, 1984
Acrylic, oilstick, and photocopy collage
on canvas, 180 x 261 cm (70¾ x 102¾ in.)

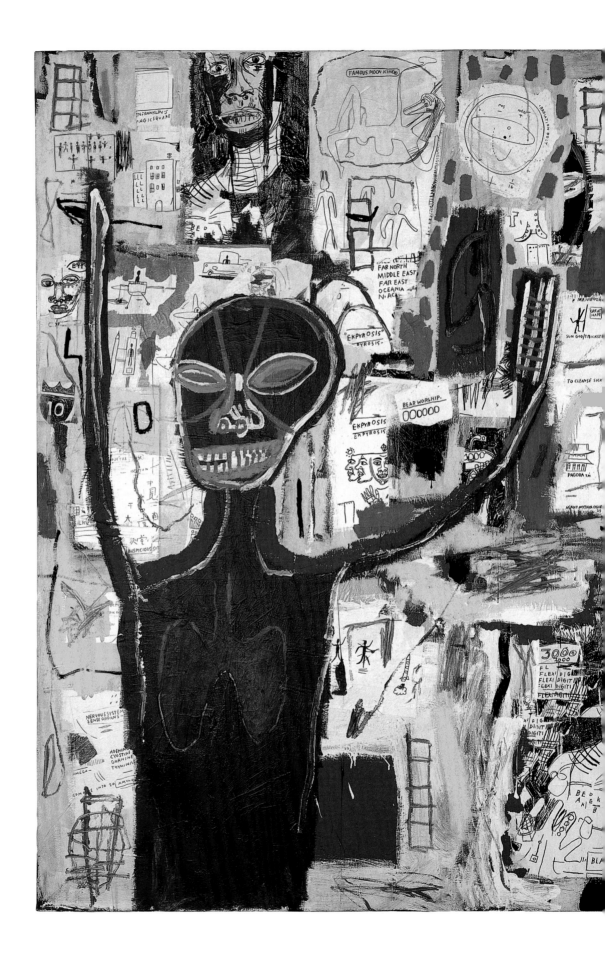

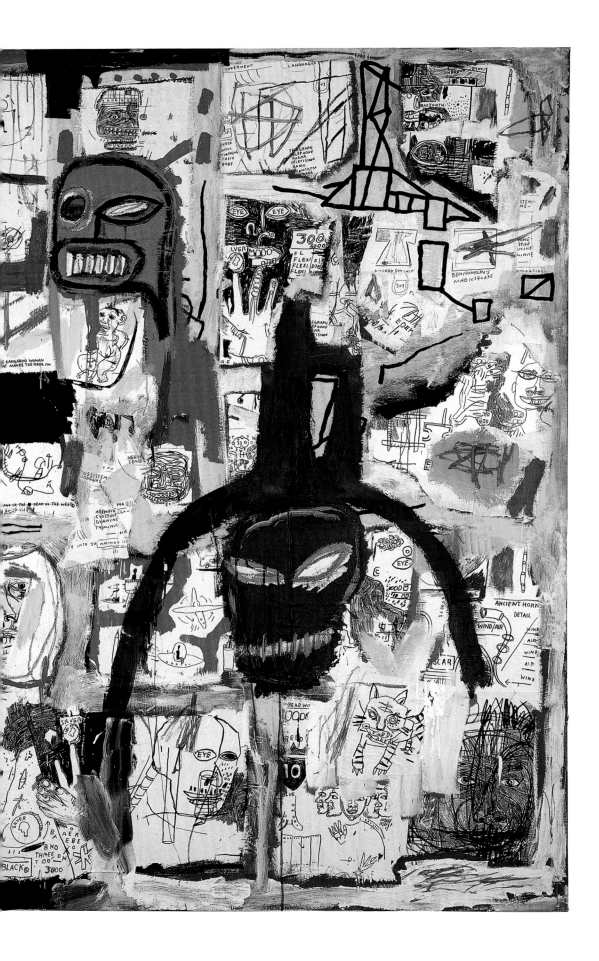

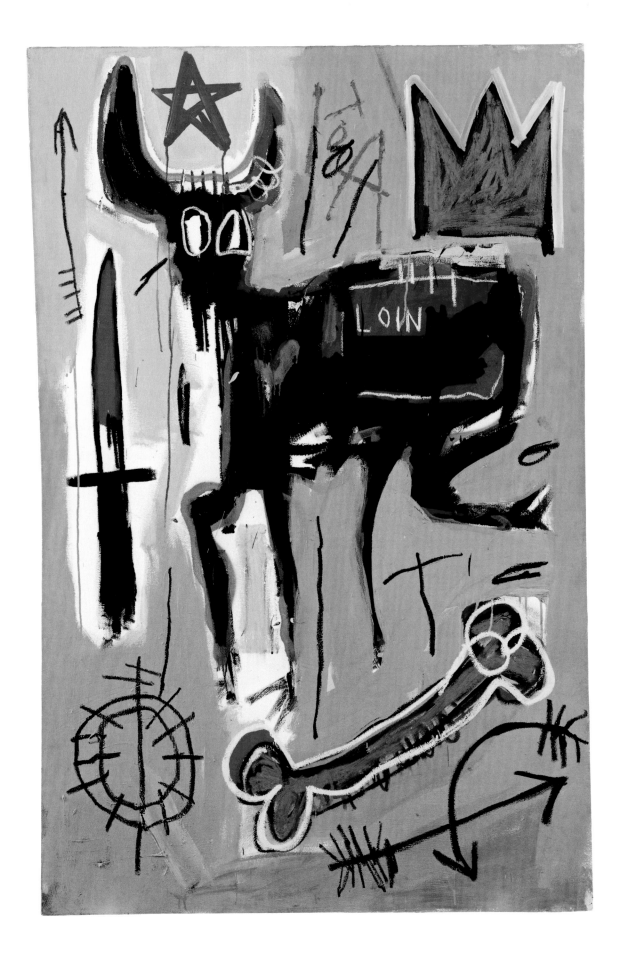

"Profit I"
In the Art Business

Basquiat briefly broke off the preparations for his first show at Annina Nosei's gallery in March 1982, taking a short trip to Puerto Rico and the nearby island of Culebra. He brought along a painting he had already revised several times, *Arroz con Pollo* (ill. p. 58 bottom), in which a male figure extends a plate with a broiled chicken on it towards a seated woman. The narrative content is hardly spectacular, but the scene is dominated by a feeling of terror. The woman holds her right hand to her left breast as though offering it to the man as a gift, but her hair stands fully on end, and her masklike distorted visage suggests she is in the grip of an unspeakable horror. The man wears a steel crown/crown of thorns and extends the meal to her with an almost humble glance, to the side. The form of the woman's porcupine hair is repeated in her arm, which is mutated into a kind of stick-figure grasping tool; in the rake-like legs of the man; and in the skeletal features created through several non-figurative lattice structures, all serving to reinforce the impression of threat and an undercurrent of violence.

This painting has been described as one of a handful of Basquiat works that depict an interior. But other than the stick-figure forms of a table and chair, the image contains nothing that indicates whether the location is inside or outside. The further claim that Arroz con Pollo has one of the few female figures portrayed in Basquiat's work is simply false. Many paintings after 1982 include abbreviated figures described as Venuses. The *Untitled (Venus)* of 1983 (ill. p. 58 top), among the most monumental of the works, conveys a force and power that unmistakably demonstrate the influence of Dubuffet's *Corps des Dames* group from the early 1950s. The flatly drawn, grinning head of the woman is cut off by the top edge of the painting. The observer sees a monstrous, armless torso with circular breasts, belly button and pubis. The contours are rendered by black agitated lines. As in Dubuffet's *Botanique et géographie*, the same pastose application of color fills both the figure and background. The brownish coloration suggests an equivalence of the female body with the earth, with matter itself. That the body itself can also be read as a face suggests further inspiration from Dubuffet.

Basquiat's other depictions of women are clearly influenced by fashion drawings or relate to the crassly sexual, like 1985's *Tit* and 1984's *Callgirl*. Basquiat paid tribute to singer Billie Holiday (1915–1959) as a black hero in *Billie*, created in the years 1983 to 1987. His strong preoccupation with the Western tradition of

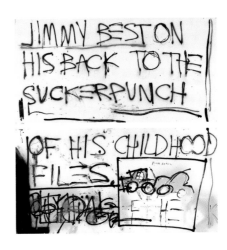

Jimmy Best, 1981
Spray paint and oilstick on metal panel, diptych: 244 x 244 cm (96 x 96 in.)

Loin, 1982
Acrylic, oilstick, and pastel on canvas, 183 x 122 cm (72 x 48 in.)

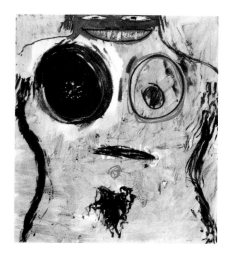

Untitled (Venus), 1983
Acrylic and oilstick on canvas,
169.5 x 154.5 cm (66¾ x 60¾ in.)

female portraiture is clear in his many paraphrases of the best-known painting in the world, Leonardo da Vinci's *Mona Lisa*, as in *Lye* (1983) and *Mona Lisa* (1983, ill. p. 62). In a dubious homage to his gallerist, Mary Boone, who dealt his work from 1983 to 1985, he mounts Boone's visage on a hardboard, repainted reproduction of the *Mona Lisa* (ill. p. 10), titled *Boone*. Insofar as the *Mona Lisa* still survives today as an ideal of beauty or femininity, Basquiat's paraphrase is a mocking farewell to all that – and a vicious commentary on Mary Boone's own vanity. Basquiat's transformation of the *Mona Lisa* into caricature reaches its high point in 1982 with *Crown Hotel (Mona Lisa Black Background*; ill. p. 59), in which a female figure is combined with comic-book faces and captions like "MONA LISA – SEVENTEEN PERCENT MONALISA FOR FOOLS – OLYMPIA." Basquiat repeats the latter reference in *Three Quarters of Olympia Minus the Servant*, 1982, and *Untitled (Maid from Olympia)*, 1982, two painted broadsides targeted at Édouard Manet's legendary *Olympia* of 1863, a seminal work of early modernism. If a black woman is a rarity in European painting, it is all the more indicative of an underlying racism when one does appear, as in Manet's work, merely as the servant of a naked white-skinned beauty.

Culebra was also where Basquiat painted *Acque Pericolose* (*Poison Oasis*, 1981; ill. pp. 12/13). On the left half, this work features the now-familiar figure of the naked black man with a nimbus or thorns. He is threatened from the left corner by a green snake, while the right half of the painting depicts the skeleton of a bovine surrounded by flies. Above this cadaver, we can recognize the poisoned spring of the title. The surface has been painted over several times, combining sprayed sections with designed color fields in oil and gestural drawings. The colors shimmer from glowing yellow to the beige of desert sands. The precariousness, abandonment and helplessness of human existence emerges powerfully in the protagonist's situation, trapped as he is between the venomous fangs of the snake and the poisoned death-bringing water. Here existential solitude is

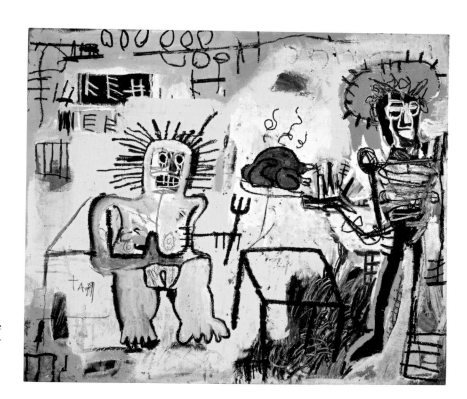

Arroz con Pollo, 1981
Acrylic and oilstick on canvas,
172.5 x 213.5 cm (68 x 84 in.)

Arroz con Pollo is an example of Basquiat's use of a variety of stylistic techniques in one painting. It is also representative of the recurring problems between men and women in Basquiat's work.

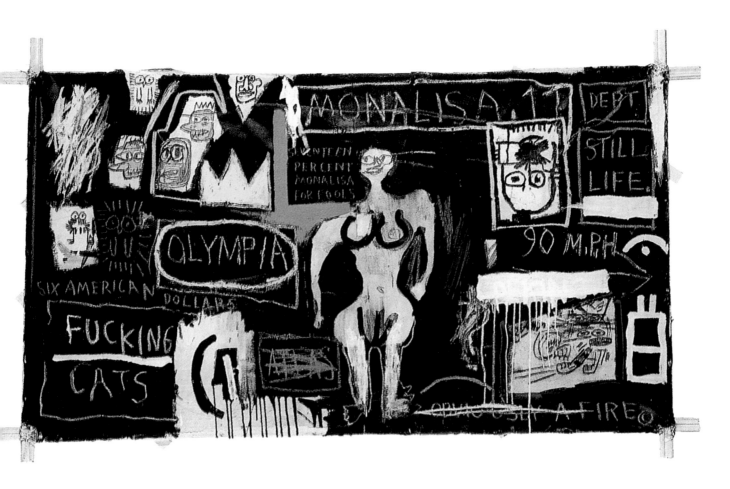

conveyed through three universal and directly comprehensible, timeless images: snake, skeleton, naked man.

At the Annina Nosei show in March 1982, Basquiat hung *Arroz con Pollo* and the *Self-Portrait* (ill. p. 44) alongside *Per Capita* (ill. pp. 64/65). The central figure of the latter is a black boxer with a nimbus, holding a torch in his upraised left hand. Jeanne Silverthorne, writing in *Artforum* (Summer 1982, p. 82), sees the boxer as a figuration of the Statue of Liberty – an interpretation suggested by the caption Basquiat wrote above the boxer: "E Pluribus." Those are the first words in "E Pluribus Unum" – "Unity From Many," the (invented) Latin motto of the Great Seal of the United States, proposed originally by John Adams, Benjamin Franklin and Thomas Jefferson in 1776. The motto defines the mission of forming one union from the 13 original states, but also warns of the difficulties in integrating citizens of differing cultures, education and religious convictions into a unified society without doing violence to their individual identities. As a symbol of light, the torch points to the Enlightenment ideas of liberty, equality and fraternity, as raised in both the French Revolution and the Constitution of the United States. The torch-bearing boxer thus symbolizes the ideals counteracted by "per capita," a term used by economists to indicate individual shares of costs or wealth, as in "per capita income." Here the high ideals of the founding fathers of American society stand in contrast to the banal power of money, the hope of creating a great common nation is counteracted by racial discrimination, and the American sense of mission is confounded by real economic misery.

Silverthorne was especially intrigued by Basquiat's miniature "poem drawings," one of which we have already seen in *Milk©*. These quote from the myste-

Crown Hotel
(Mona Lisa Black Background), 1982
Acrylic and collage on canvas, mounted on wooden supports, 124 x 216 cm (48¾ x 85 in.)

rious sayings once sprayed on building walls by Basquiat-alias-SAMO, and generally take on the problem of racism, as in *Tar Town* and *Origin of Cotton*. The longest of these poems, rendered as the 1981 painting *Jimmy Best…* (ill. p. 57), presents the compact biography of a black man: "Jimmy Best / on his back to / the suckerpunch / of his childhood files."

"As anyone who has done time at the Riverhead Reformatory can tell you, the cleverest, strongest, most determined, most intelligent and greatest Blacks and Latinos are systematically neutralized and discouraged by the strict rules of the prison," René Ricard wrote of this poem. "Their idea is to get you while you are still young. Jimmy (the best), will never manage to escape his imprisonment (suckerpunch) as a youthful lawbreaker (childhood files), for his life is destroyed by a prison system that perpetually reaffirms its original judgment. This is the black man's first encounter with White justice."

Silverthorne views Basquiat's picture-poems as a positive counterweight to the large-format paintings: "Small and simple are the plan's market-crier ambitions … A clever head and a gifted hand are clearly at work; if Basquiat can combine the two, so that the one does not contradict the other, he may yet avoid getting ulcers from the demand that he constantly rehash his success." (*Artforum*, Summer 1982, p. 83).

The second stay with Mazzoli at Modena seems to have been a turning point for Basquiat. He reacted to the awkward situation there with *The Man from Naples* (1982, ill. p. 61), which shows a red animal head, probably that of a pig. Along with the crown and dollar-sign motifs, the diptych contains a thick verbal profusion in blue, black and red: "Mercanti di Prosciutto," "Porkchops,"

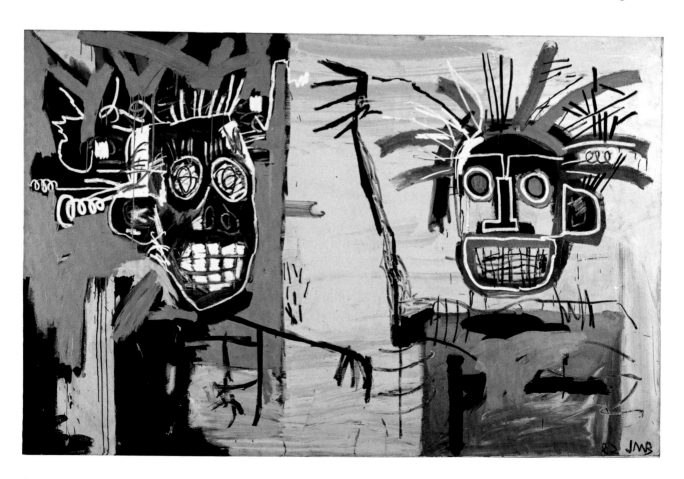

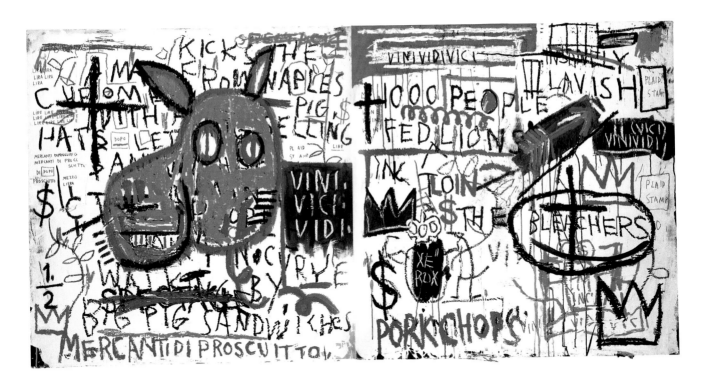

"Big Pig Sandwiches," "Vini Vici Vidi," "Fed Lion," "The Bleachers," "Lavish."
These exemplify the ambivalence of Basquiat's situation; "Lavish," "Big Pig
Sandwiches" and the Italian phrase for prosciutto merchant no doubt refer to
Mazzoli, who traded in pork and was known for his great generosity and hospi-
tality. The false version of Caesar's famous statement, "veni, vidi, vici" ("I came,
I saw, I conquered") and the crown express Basquiat's high at having reached a
new summit in his career. But "Fed Lion" and "Bleachers" (which might refer
equally to chemicals used by some blacks to lighten their dark skin, or to the
cheap seats in a baseball park) directly address the problem of Basquiat's skin
color. "Fed Lion" is also an angry shot at the greed of Mazzoli, Nosei and
Bischofberger, who constantly resold Basquiat's works among themselves,
driving up the prices.

"They set it up for me so I'd have to make eight paintings in a week," the
angry young artist later told an interviewer for *The New York Times Sunday
Magazine*. "Annina, Mazzoli and Bruno were there. It was like a factory, a sick
factory. I wanted to be a star, not a gallery mascot."

Nevertheless, each show was followed by another, even more successful one.
Nosei's business partner Larry Gagosian put on an all-Basquiat show at his
gallery in Los Angeles in April 1982. All of the exhibited pieces were sold out on
the evening of the opening, including two versions of *Tar and Feathers, Untitled
(Red Warrior), Untitled (Black Skull), Untitled (Two on Gold*; ill. p. 60), *L. A.
Painting, Untitled (Black Figure), Loin* (ill. p. 56) and *Six Crimee*. The slick
Gagosian charmed the cream of Los Angeles collectors into visiting his gallery,
and Basquiat obligingly defied them with his bad-boy attitude. Incessantly
sucking on his marijuana spliffs, his Walkman headphones always on his ears,
he mocked everyone who tried to talk to him. Basquiat stayed in Los Angeles
for six months, and thereafter traveled to California several times a year until
his death.

The Man from Naples, 1982
Acrylic, oilstick and paper collage on wood,
diptych: 122 x 244.5 cm (48 x 96¼ in.)

Untitled (Two on Gold), 1982
Acrylic and oilstick on canvas,
203 x 317.5 cm (80 x 125 in.)

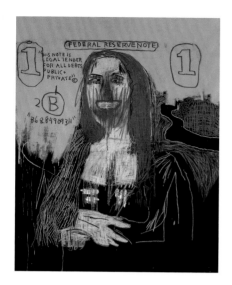

Mona Lisa, 1983
Acrylic and oilstick on canvas,
169.5 x 154.5 cm (66¾ x 60¾ in.)

At documenta 7 in the summer of 1982, Basquiat, Lee Quinones and Signe Theill became some of the youngest artists ever to have their work exhibited at the quintennial of contemporary works in Kassel, Germany, the most important of all events on the Western art calendar. The show featured five Basquiat paintings: *Arroz con Pollo* (ill. p. 58), *Untitled (Man at Left), Untitled, Acque Pericolose* (ill. pp. 12/13) and *Crowns (Peso Neto)*. Meanwhile the first one-man exhibition of Basquiat's work was being organized in Zurich by Bischofberger, using works he owned, in time for an opening in September 1982. Bischofberger thereupon took on the rights as Basquiat's exclusive dealer in Europe.

The Zurich exhibition showed for the first time the characteristic rough frames on which the canvases were stretched. As a result of this technique, the canvases were transformed from two-dimensional painted surfaces into haptic three-dimensional objects, reminiscent at the same time of African shields, Polynesian sailboat rigging, and Spanish devotional objects. Basquiat used other, even less conventional surfaces to paint on, such as doors, window frames and refrigerators. These were *objets trouvés*, dragged by his assistant into the newly occupied studio on Crosby Street.

This loft had been found for him by Annina Nosei. During this period in spring 1982, Basquiat shared his reclusive life only with his assistant Torton, who also accompanied him to Zurich for a week's stay at Bischofberger's. The artist himself gave his undivided attention to his art. The painting *Bruno in Appenzell* (ill. p. 62 bottom), a childlike picture in friendly pink, recalls their trip to the resort of the same name. The caption "ESSEN," the German word for food, plays on the gallerist's passion for culinary delights.

Basquiat had a powerful ulterior motive in cultivating his relationship with Bischofberger. Quite apart from the Swiss connoisseur's qualities as a gallerist and dealer in general, he also happened to be Andy Warhol's gallerist and dealer. At first, Warhol was quite reluctant about meeting the young Basquiat. When Bischofberger brought Basquiat to lunch at Warhol's legendary Union Square studio, the Factory, on October 4, 1982, Warhol was mistrustful, asking Bischofberger whether Basquiat was really a great artist. Bischofberger confirmed this. And for this reason, Bischofberger added, he was asking Warhol to make a portrait of Basquiat. Warhol's photographer, Chris Makos, obligingly took a few Polaroid stills of Warhol and Basquiat together. At that point, Basquiat suddenly left the premises and went back to his studio and painted the portrait of Warhol and himself. Stephen Torton soon returned to the Factory with Basquiat's painting, still wet, much surprising Bischofberger and Warhol, who were still at lunch.

Dos Cabezas (1982, ill. p. 67), Jean-Michel's fast painting, shows a realistic Warhol raising his right hand to his face, one of his signature gestures. Basquiat drops any pretense of accuracy in rendering his own face as a child-like caricature, grinning wildly. Warhol, who greeted Basquiat with the words, "Do you still sell your paintings for a dollar?" now woke up to the reality that Basquiat's works were selling for up to $20,000 in Zurich and Düsseldorf, and that he was the rising star of an art world that was leaving Warhol behind. This was no doubt essential in Warhol's decision to enter an artistic collaboration with the young artist, following a proposal that Bischofberger had already made to him a year earlier.

Meanwhile, an initially hesitant Basquiat had agreed to do a November 1982 show at the Fun Gallery, in the radical bastion of the East Village. This escape from SoHo was an effort to regain some street credibility with his old pals from

Bruno in Appenzell, 1982
Acrylic and oilstick on canvas, mounted on wooden supports, 139.5 x 139.5 cm (55 x 55 in.)

the graffiti and rap scene – and a protest against the exploitation and marketing of his own person, which had so disgusted him during his time in Modena as Mazzoli's "gallery mascot." The prices at the Fun Gallery were set far below Basquiat's usual market value. For just 750 dollars, Aninna Nosei bought *Philistines* (ill. pp. 38/39), which she would later sell for 15,000 dollars, and Basquiat received neither that purchase sum nor any share of the other sales at the show. But the financial aspect of the event apparently meant less to him than that the statement it represented.

The 30-odd paintings at the Fun Factory included *Piscine versus the Best Hotels, Future Science versus the Man, The Bond, Earle or Stanhope, Three Quarters of Olympia Minus the Servant, Head of a Fryer, Santo versus Second Avenue, Untitled (100 Yen), Untitled (Thor)* and *Sugar Ray Robinson.* The press echo was everything Basquiat had hoped for.

The Dingoes That Park Their Brains with Their Gum, 1988
Acrylic and oilstick on linen,
254 x 289.5 cm (100 x 114 in.)

PAGES 64/65
Per Capita, 1981
Acrylic and oilstick on canvas,
203 x 381 cm (80 x 150 in.)

In its references to American history and peculiar modification of symbols like the Statue of Liberty, *Per Capita* stands out as a conscious appropriation and transformation of preexisting materials in the creation of a unique visual message.

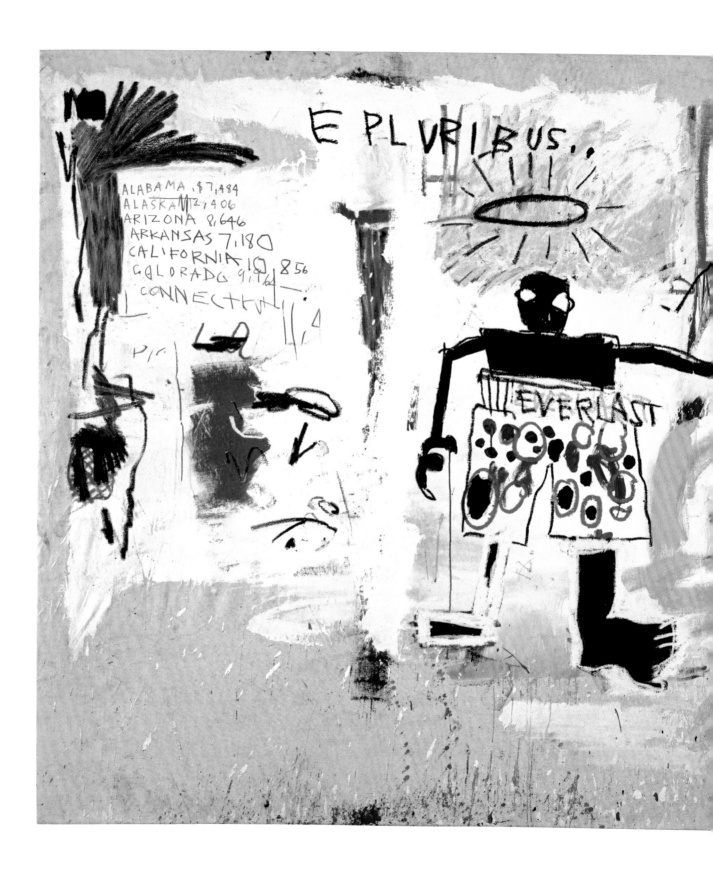

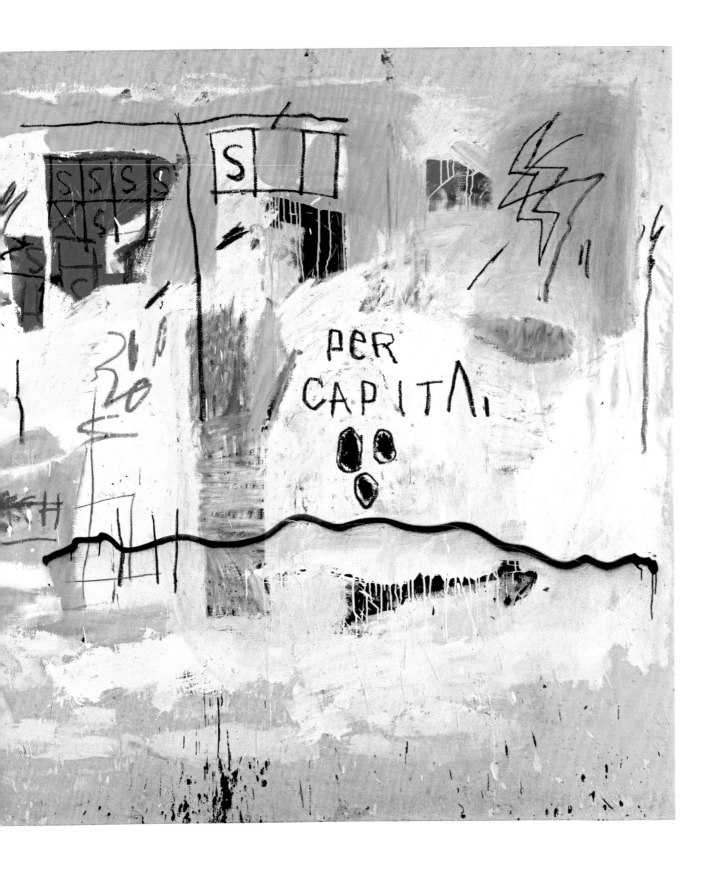

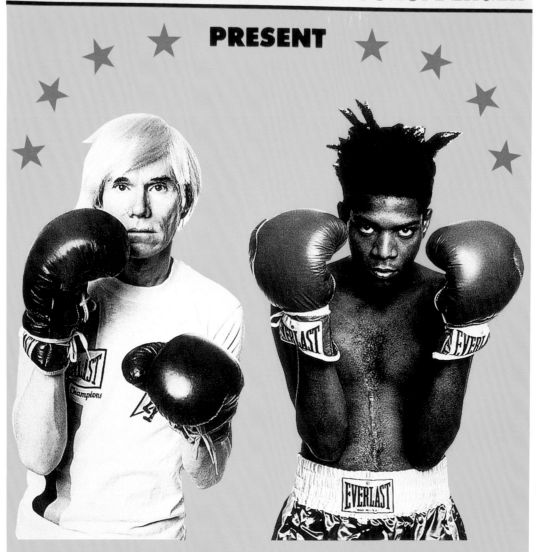

"Dos Cabezas"
Basquiat and Warhol

Warhol's 1982 portrait of Basquiat, a silk screen on canvas, was one of his "piss paintings," meaning the colors were oxidized by evaporating urine after he pissed on the finished canvas. Warhol began experimenting with urine as far back as 1962, and from 1978 he developed the piss-paint technique as a way of introducing a random element – an ironic paraphrase of the hero of Abstract Expressionism, Jackson Pollock, with his drip technique. By then this was one of Warhol's accustomed techniques, and so urinating on the portrait was not meant as a comment on Basquiat's person. But the photo later became an inadvertent source of grief to Basquiat, starting in 1985 when his face began to break out in dark patches disturbingly similar to the ones caused by urine oxidation in Warhol's portrait. This was almost certainly a late symptom of the childhood operation to remove Basquiat's spleen. Probably as a result of the operation, his blood was no longer able to clean itself. The later photographs of Basquiat, from 1986, show a face strewn with patches (ill. p. 92).

The image of Basquiat with the wild dreadlocks, as he painted himself in *Dos Cabezas* (ill. p. 67), was immortalized in a series of black-and-white stills (ill. p. 93) taken in a 1982 photo session by James Van Der Zee, long known as the "photographer of the Harlem Renaissance." Commissioned by Diego Cortez, these shots accompanied the publication of Henry Geldzahler's interview with Basquiat. Returning the favor, Basquiat painted a portrait of Van Der Zee and titled it *VNDRZ* (ill. p. 68), making an acronym out of the name. Van Der Zee's photographs contributed to the image of Basquiat as a young, angry black artist who demands respect, self-confidently enthroning himself as he snubs the conventions of bourgeois society.

In early 1982, Basquiat made a series of 18 silk screens for Annina Nosei, entitled *Anatomy*. With art dealer Fred Hoffman, he produced a second such series in Los Angeles during his stay there in the winter of 1982–83. As a gift, Hoffman gave Basquiat the volume of da Vinci sketches that was to exercise a lasting influence on his work. Hoffman was also the owner of the Profile music label, under which he put out *Beat-Bop*, a rap music milestone for which Basquiat did the cover. Basquiat produced the album in 1983 together with Rammellzee, Toxic, Al Diaz and Fred Brathwaite. An instant collector's item, the record is still a source of inspiration to artists like Tricky, as one of the first steps in the evolution of Trip Hop and Ambient Rap.

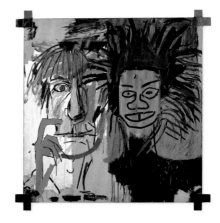

Dos Cabezas, 1982
Acrylic and oilstick on canvas mounted on wooden supports, 152.5 x 152.5 cm (60 x 60 in.)

Dos Cabezas documents Basquiat's triumph in achieving a long yearned-for relationship with Andy Warhol, the Pope of Pop. Basquiat's assistant was dispatched to bring the still-wet painting to the honored father figure on the evening of its creation.

Warhol – Basquiat. Paintings, 1985
Poster for "Collaborations Exhibition"
New York, Tony Shafrazi Gallery

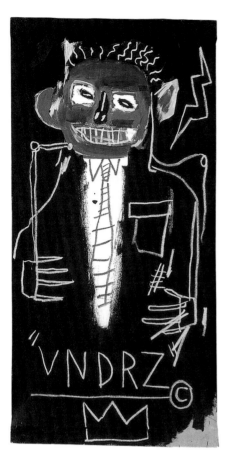

VNDRZ, 1982
Acrylic and oilstick on canvas,
152.5 x 76 cm (60 x 30 in.)

Basquiat's longstanding yearnings to break into the museum world were fulfilled in March 1983, when he was chosen for the Whitney Biennial along with Keith Haring, Jenny Holzer, Barbara Kruger, David Salle and Cindy Sherman. Just 22, he was (as at documenta 7 a year earlier) one of the youngest artists ever shown at the most important American exhibition of contemporary art. His works there included *Dutch Settlers* and *Untitled* (*Skull*; ill. p. 69). At the dinner following the Whitney opening, Basquiat met Mary Boone, who would represent him during the next two years alongside Bruno Bischofberger. The latter, who did not want exclusive responsibility for Basquiat, had previously asked Boone to join him in the task on several occasions. The young Boone could look back on her own quite recent meteoric rise to prominence. She was the first dealer to perfect the waiting-list principle, tying artists and collectors alike to herself as the hub in an ever-spinning wheel. To further an artist's career, she would make sure that he caught the eye of the right critics at the right time, that his works were shown in the right exhibitions and that she hosted the necessary parties.

Just before she decided to take on Basquiat, Boone had lost Julian Schnabel, her most prominent artist, to the Pace Gallery. Basquiat was an expedient antidote, although a countertrend to Neo-Expressionism and the declining East Village art scene was underway with the rise of a new movement known as Neo Geo. Basquiat took little notice of all that; his star was still very much on the rise. He once again sought to get nearer to Warhol via Paige Powell, advertising director of Warhol's magazine, *Interview*.

Warhol continued to show reserve and a lack of interest, until he became convinced of the advantages in working with Basquiat. The "Prince of Boredom" had begun to bore his audiences. Warhol's endless repetitions of the banal – his most recent series were devoted to knives, revolvers and dollar bills – appeared jaded by comparison to the explosive vitality of the Neo-Expressionists. His shows, especially in New York, were accordingly unsuccessful, few if any works being sold. Warhol had always sought contacts with artists, musicians or actors who represented an opposite pole to his own position in one way or another. At this point in time, Warhol apparently thought Basquiat was the best bet to help give his career a boost.

A kind of friendship arose between Basquiat and Warhol. Together they frequented openings, fitness studios and clubs. Powell arranged for Warhol to acquire and rent to Basquiat a new studio on Great Jones Street, of which Jean-Michel took possession on August 15, 1983. He was to live there until his death in August 1988.

In October 1983, Basquiat accompanied Warhol to Milan, before going on to Madrid with Keith Haring. At the end of the year, a few weeks after a second one-man show in Zurich from September 24 to October 22, 1983, Basquiat paid a further visit to Bischofberger, this time in St. Moritz. On this occasion, after seeing Basquiat draw together with his daughter Cora, Bischofberger had the idea of convincing Warhol to work together with Basquiat. Bischofberger had arranged two previous artistic team-ups, both with success: Walter Dahn and Georg Dokoupil, and Enzo Cucchi and Sandro Chia. But this time he wanted a threesome. Bischofberger and Warhol briefly considered, and then ruled out Julian Schnabel as the third partner. Finally, Bischofberger decided to ask Francesco Clemente to join in the triple trick. Each of the artists was supposed to begin four paintings, without discussing them with anyone in advance, but keeping in mind that the works would be completed by the other two artists.

Untitled (Skull), 1981
Acrylic and oilstick on canvas,
207 x 175.5 cm (81¼ x 69 in.)

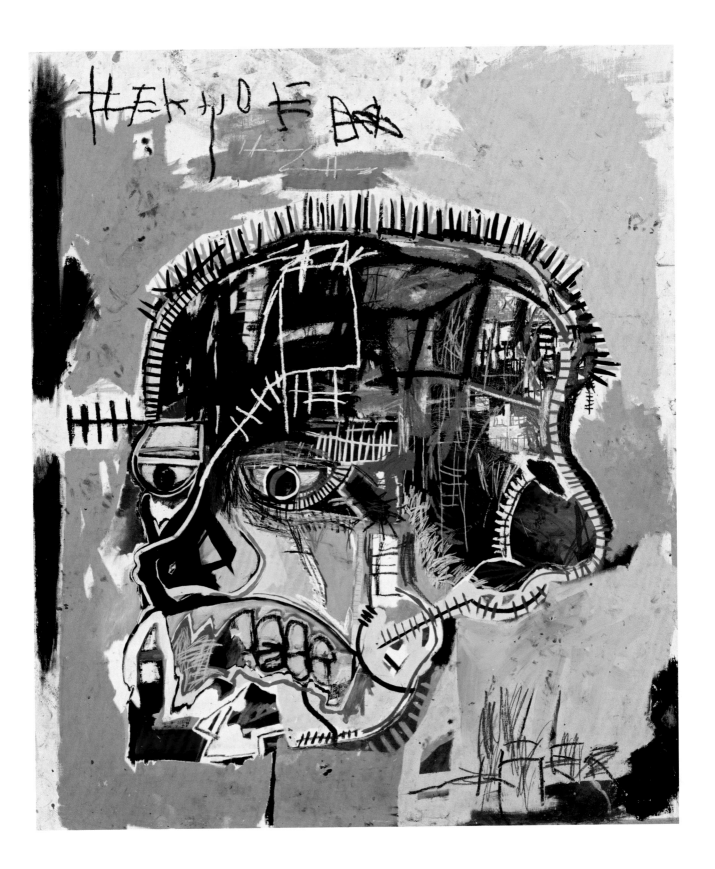

The three men began to trade their pictures among each other, until these were judged complete. Basquiat and Clemente came up with a title for the exhibition during a joint holiday near Rome in the summer of 1984, and Bischofberger finally showed 15 of these *Collaborations* at his gallery from September 15 to October 13, 1984.

Now Basquiat and Warhol continued to paint together, this time without telling Bischofberger about it. In defense of their secrecy, Warhol later argued that Bischofberger had not commissioned these paintings, but of course he retained the right of first buyer – of which he directly made use. Warhol had not painted in more than 20 years; inspired and encouraged by Basquiat, he was willing to finally pick up a brush. Basquiat never tired of claiming this as his own achievement, and it was a major element in marketing the resulting works.

On the whole, the *Collaborations* by Basquiat, Clemente and Warhol were negatively received. Writing in *Artforum* (XXIII, No. 6, Feb. 1985, p. 99), reviewer Max Wechsler found much to criticize. "Basquiat's scribbles, Clemente's soulful figures and Warhol's silk-screen techniques all display visual brilliance, but they fail to enter a real dialogue or interact in a way that lends any new dimensions. On the contrary, they are placed around each other as parts of a collage in which the various parts barely contribute anything to a common whole… Is this because of the artists' mutual fascination in each other's works, or was it all done on a whim, in a desire for fun and adventure?" Of course, the *Collaborations* had no such romantic background; the idea was Bischofberger's, and he thought it was good business.

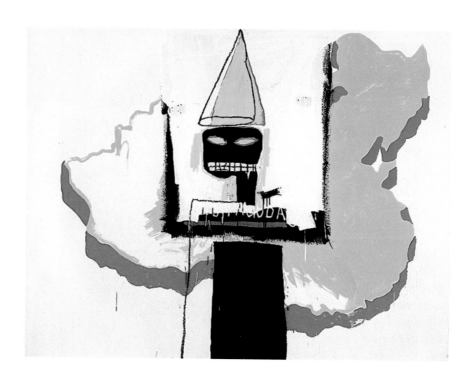

China (with Andy Warhol), 1981
Acrylic on canvas,
139 x 260 cm (54¾ x 102¼ in.)

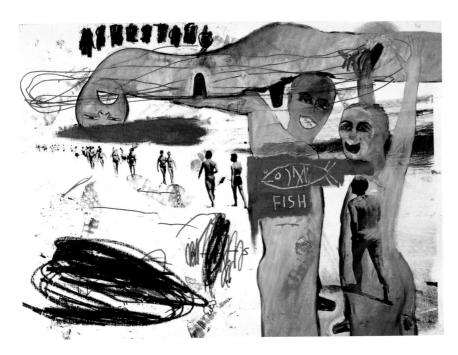

Cilindrone (with Francesco Clemente
and Andy Warhol), 1984
Oil, acrylic, crayon, and silkscreen on canvas,
122 x 168 cm (48 x 66¼ in.)

Gallerist Bruno Bischofberger's idea of
arranging collaborations between Clemente,
Basquiat and Warhol gave rise to only a
handful of worthy works. *Cilindrone* is
among the better results.

One of the stronger *Collaborations* is *Cilindrone* (1984, ill. p. 71), in which
Clemente's naked figures dance in peculiar fashion around Warhol's silk
screens, creating an existence that is equal parts Arcadia and savagery, within
which Basquiat's scribbles and crossed-out words seem to fit organically. In
Pole Star, Warhol simply reacts to the image his collaborators provide by
translating it into series production. But in a work like *Alba's Breakfast,* which
was named after Clemente's wife Alba, the individual elements fail to fit into
a greater whole. Basquiat's scribbles and copyright signs seem pointless.
No dialogue arises between the figures. Unavoidably one asks what in the
world Warhol's General Electric logo and washing machine are doing in this
picture at all.

Turning to the subsequent Warhol-Basquiat works, one wishes they had
been more serious about Warhol's claim that the results would be best if
the observer could no longer recognize which artist had authored which ele-
ment. Trifles like *Eiffel Tower* and *Bananas* gain no coherence through the
mere use of a painted frame. Very much in love with themselves, the two artists
toss their little playthings back and forth; and the use of a banana motif, already
a kind of Warhol trademark since his cover for the first Velvet Underground
album, is simply overbearing. Basquiat had already used the same figure of
a half-peeled banana as a means of showing reverence to his adopted father-
figure in 1984's *Brown Spots*. However, at least one piece, *China* (ill. p. 70),
undeniably conveys something of the fascination of the Middle Kingdom –
at the time still a rather mysterious and closed world. Given a thick 3-D contour
in red, the gigantic country's shape becomes a kind of plateau. This nearly
homogenous area is counterpointed by one of Basquiat's typically diabolical
heads, which wears a hat reflecting the same yellow as the map. We know that
the original working title of this painting was *The Plague,* which may explain
the terror that the figure inspires.

Basquiat's first one-man show at Mary Boone's opened on May 5, 1984. The catalogue began with a "Poem to Basquiat" by the German painter A. R. Penck. Years later, Penck's verse would be recited at Basquiat's funeral by his girlfriend of many years, Suzanne Mallouk, and already in 1984 the words clearly foreshadow the farewell yet to come. In part it reads:

"(…) be careful baby / what means automatism / after the night / break the fascism / the original cataclysm / the big splash / the hard crash / be tide / only with feeling / the last thing / without a cry / I say to you goodbye."

Basquiat's work subsequently appeared in "An International Survey of Recent Painting and Sculpture," the first exhibition after the reopening of the Museum of Modern Art. In August 1984, the Fruitmarket Gallery in Edinburgh opened Basquiat's first one-man museum show, which went on to further venues at the Institute for Contemporary Art in London and the Museum Boijmans Van Beuningen in Rotterdam. His works brought in record receipts. At the Christie's spring 1984 auction, *Untitled* (*Skull;* ill. p. 69) sold for the substantial sum of 19,000 dollars, a rise of 375 percent over its sale the previous year for just 4,000 dollars.

And then came the publication of February 10, 1985, which seemed to mark a new high point in Basquiat's career, but which in retrospect foreshadowed his downfall. There was a seated Basquiat, casually slouching on the cover of *The New York Times Magazine*. The photo accompanied an interview with Cathleen McGuigan under the headline: "New Art, New Money – The Marketing of an American Artist." More interesting than the article was the form of self-presentation chosen by the artist, an illuminating contrast to the earlier photos by Van Der Zee. Basquiat reclines, barefoot, against the back of a seat, with his latest *Untitled* (1985) in the background (ill. p. 2). His gaze is comparable to the calm and distanced, mildly hostile look from the Van Der Zee pictures (ill. p. 93). His left hand at his chin, he holds a thin brush between two fingers in the right. In an often-published shot from the same session, the posture is modified: the left hand leads to the chin, the brush held more loosely in the right. But on the *New York Times Magazine* cover, the brush is held like a weapon. There, Basquiat chose the image of the angry young rebel, elsewhere preferring that of a dandy.

Not just the arrangement, even the colors were carefully considered. The black of the suit reflects the black figure in the painting on the right, the red of the fallen chair repeats the red surrounding the hatted figure on the left. The heads of the painted figures are on a level with Basquiat's own, making them into a sort of imaginary following. All the ambivalence of Basquiat's life is evident here: the self-consciousness with which he wears the suit, the simultaneous dismissal of this paint-spattered status symbol, the dandy's sense of style, the willed rejection of social convention in the bare feet. Not unlike his appearances at openings, with headphones over his ears, or his much-feared attacks on his own gallerists.

At Boone's, he used to walk in unannounced, dressed in his pajamas, and chase away possible collectors with his arrogant conduct. The fallen chair of the photo, at first glance merely a symbol for creative disorder and hence of the genius artist cliché, on further consideration acquires a more aggressive connotation: "His naked foot rests on the fallen chair in a parody of these photos of white hunters, where the rifle-wielding bwana with a tropical helmet poses with his boot on a cadaver. Basquiat was always a terribly elegant fop." (Dick Hebdige). Basquiat is modifying the traditional safari hunter's victory

Pyro, 1984
Acrylic and silkscreen on canvas,
219.5 x 172.5 cm (86½ x 68 in.)

pose by replacing the white man a black one, rifle with paintbrush, boot with naked foot. The suit, the white middle-class fetish, is worn as self-evidently as it is with disdain for the values it represents.

Basquiat entered his second show with Mary Boone, which opened in March 1985, with obvious reluctance. Boone and Basquiat went at each other constantly in advance of the opening, culminating, according to Boone, in his attempt to beat her up at the opening. Their business relationship ended immediately after the show, but Basquiat took no break from his hectic lifestyle. He spent April 1985 in Hong Kong with the restaurateur Mr. Chow, whose meals he often recompensed with paintings. In May, he and his girlfriend of those years, Jennifer Goode, took up collector Marcia May's invitation to visit her in Dallas. Later that month, he finished a wall painting at the just-opened latest New York "in" club, the Palladium, a job arranged by Henry Geldzahler. Other paintings at the Palladium were by Francesco Clemente, Kenny Scharf and Keith Haring. Basquiat, Goode and photographer Michael Halsband flew to Paris in July, and from there they continued to Lisbon, Rome and Florence. Then Goode went back to the United States and Basquiat proceeded to St. Moritz, once again to paint at Bischofberger's chalet. One evening, he and one of his earlier assistants, Leonart DeKneght, took a taxi for a 1,100-dollar ride, making their way via Portofino and Carrara to Florence, where they visited the museums and hung around.

Basquiat's second set of *Collaborations,* with Warhol alone, had been made without Bischofberger's knowledge, but it was Bischofberger who arranged for the works to be shown at the Tony Shafrazi Gallery in New York, from September 14 to October 19, 1985. Shafrazi had once been a graffiti artist himself, achieving his moment of notoriety in 1974 as the man who sprayed the foot-high words "Kill Lies All" on Picasso's *Guernica.* He later acquainted Basquiat with his cousin, Vrej Baghoomian, the man who became Jean-Michel's final dealer. The poster for the Shafrazi show (ill. p. 66) stylized the partnership into a prize fight, with Warhol and Basquiat standing shoulder to shoulder, arms crossed, wearing gloves and Everlast shorts.

It seemed like a perfect match, the beginning of a success story for the long term. Andy Warhol and Jean-Michel Basquiat, both equally at home in the art scene and in the gossip columns of the New York press, both profiteering off each other: the one gaining a protégé who was a genius, the other gaining a patron and father figure of worldwide renown. But the two were also equally thin-skinned about the critics, and the critics ruined the marriage with their mainly negative, when not downright devastating reviews. Vivien Raynor, whose review of the first show with Mary Boone had ended in a warning undertone, now declared that Warhol was manipulating Basquiat in their collaboration to the point that he had become an appendage.

Warhol was well aware of how dangerous the accusation of manipulation was, and Basquiat was deeply disturbed by the description of him as a mascot. Both knew intuitively that their partnership had hurt both, and that it was now over. Basquiat simply broke off all contact with Warhol. One reviewer raised the question: "Who is using whom?" For his part, Warhol had the greater experience, and was more hardened than the young Basquiat. Basquiat honored a father figure in Warhol, and the latter surely did feel a fatherly, perhaps even erotic affection for the wild child of the art scene. Neither was capable of a sustained friendship. In any case, Basquiat seemed to believe that art was about more than just business, whereas Warhol had surely come to believe in

his own cynicism. While Basquiat absolutely also wanted to become a star, he wanted to be a star painter; Warhol was engaged in the art of being a star as such. Nobody ever showed up the hypocrisy of capitalist society, using its own strategies, with a more perfidious perfection than Warhol, who saw his own shortage of human warmth and empathy as the simple consequence of a realistic worldview.

Glenn, 1984
Acrylic, oilstick, and photocopy collage on canvas, 254 x 289.5 cm (100 x 114 in.)

Grillo, 1984
Acrylic, oil, photocopy collage, oilstick,
and nails on wood, polyptych:
244 x 537 x 45.5 cm (96 x 211½ x 18 in.)

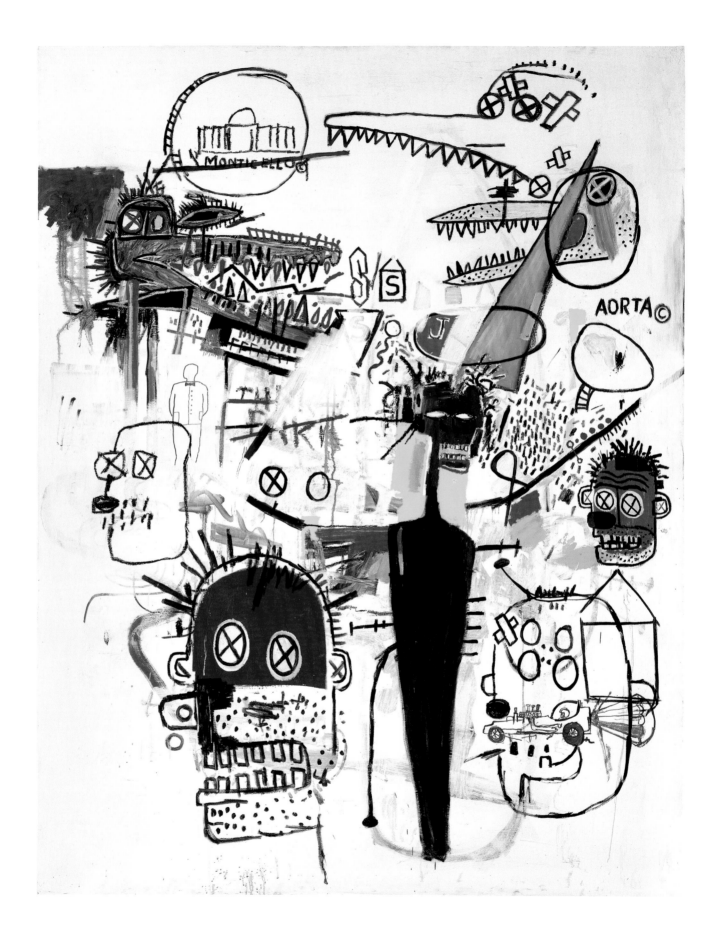

"Riding with Death"
The Final Years

In 1984, on the Hawaiian island of Maui, Basquiat for the first time rented a ranch, where he set up a studio. In subsequent years he returned there many times to recuperate from big-city life.

At Basquiat's behest, Bruno Bischofberger set up an August 1986 exhibition at the Centre Culturel de la France in Abidjan, the capital of Ivory Coast. The artist attended the opening, once again in the company of Jennifer Goode. His interest in visiting Africa perhaps was due to the influence of Shenge Ka Pharaoh, the assistant who kept his accounting books from 1983 to 1986. Shenge's cultivated mix of Black consciousness, Reggae ideology and interest in Egyptian cults may have caused Basquiat for the first time to consider seeking out an identity that did not reject or ignore his blackness, but accepted it as fundamental.

A second museum-run Basquiat retrospective was held in 1986 by the Kestner Society in Hannover, and Basquiat was interviewed on that occasion by Isabelle Graw for the German-language magazine *Wolkenkratzer*. This document is remarkable for the openness on both sides. "How do you work?" Graw asks. "I start a picture and I finish it," Basquiat answers. "I don't think about art while I work. I try to think about life." Graw: "What about the influence of Afro-Caribbean art, or of Cy Twombly, as discerned by the critics?" Basquiat: "I don't listen to what art critics say. I don't know anybody who needs a critic to find out what art is." The interview ends with Graw asking if she should come to New York before writing her article on him. "What would you do if you were writing about a dead artist?" Basquiat replied. "I would do as much research as possible, to get all of the available information," says Graw. "Then do it that way," Basquiat says. "Just pretend I was dead."

Jennifer Goode, who was probably the most important woman in Basquiat's life, separated from him in November 1986. A second shock followed a few months later with the death of Andy Warhol from complications during a gallbladder operation on February 22, 1987. Basquiat's grief was inconsolable. In memory of Warhol, he created *Gravestone* (ill. p. 80 bottom), a triptych of three castaway doors: a flower and cross on the left side, a skull with a heart engraved on it on the right. The center and highest door bears the repeated word, "Perishable." Though all living things are ephemeral, Basquiat is also suggesting that death is a passage, a door into a different form of existence.

"Hobo Signs"
From: Henry Dreyfuss, *Symbol Sourcebook. An Authoritative Guide to International Graphic Symbols,* New York 1972

Untitled, 1987
Acrylic and oilstick on canvas,
247.5 x 178 cm (97½ x 70 in.)

Pegasus, 1987
Acrylic, graphite, and colored pencil
on paper mounted on canvas,
223.5 x 228.5 cm (88 x 90 in.)

Gravestone, 1987
Acrylic and oil on wood panel,
139.5 x 175 x 56 cm (55 x 69 x 22 in.)

Basquiat began to surrender any remaining control over his life and career. He broke off relations with his dealer Bischofberger. Tony Shafrazi showed three monumental works on paper by Basquiat in May 1987, including *Pegasus* (ill. p. 80 top), and as his new dealer Basquiat took up Shafrazi's cousin, the exiled Iranian Vrej Baghoomian, who was notorious for a mysterious past and a passion for gambling.

Basquiat met Ouattara, an artist from Ivory Coast, in 1988 in Paris during the opening at Yvon Lambert's gallery. After a brief trip to Düsseldorf for the opening at Hans Mayer's and a stay in Amsterdam, Basquiat returned to Paris, where he moved into a hotel in the Marais. He and Ouattara proved to be soulmates. They planned to journey that summer to Ouattara's birthplace, Korhogo, a town Basquiat had visited by coincidence two years earlier during his first trip to Ivory Coast. Ouattara visited Basquiat in April 1988, and they traveled together to the Jazz Festival in New Orleans and visited voodoo shops. On the last day, as Ouattara recalled, Basquiat took him to see the Mississippi, a river especially redolent with African American history.

Following the last exhibition of his work during his lifetime, held at Vrej Baghoomian's gallery in April 1988, Basquiat went to Maui in June. He told his last girlfriend, Kelle Inman, of his intention to give up painting and take up writing instead. He told other friends that he only wanted to make music, or open a tequila distillery.

Back in New York, Basquiat met Vincent Gallo and told him that he wanted to leave New York and go to Africa. The tickets for the flight to Abidjan on

August 18 had already been paid for, when, six days before the scheduled departure, he died of an overdose of a cocktail of drugs. On August 12, 1988, Kelle Inman discovered the painter's body in his studio. He was buried in Greenwood Cemetery in Brooklyn on August 17. Jeffrey Deitch made a speech at the graveside. A memorial service was held at St. Peter's Church on Lexington Avenue on November 5, which was attended by more than 300 guests: there was a performance by his old friends from the band Gray, and Suzanne Mallouk recited sections of A. R. Penck's "Poem for Basquiat."

How tempting for the critic to search Basquiat's final works for a premonition of his approaching death. The two paintings *Eroica I* and *Eroica II* (ill. pp. 82 and 83) especially invite such speculation, since Basquiat himself had arranged for his picture to be taken in front of *Eroica I* with the caption "Man Dies" visible just over his shoulder, the ravages of drugs written on his face. In its pale colors, in the agitation of its gestured strokes, *Eroica II* especially recalls the work of Cy Twombly.

Riding with Death, 1988
Acrylic and oilstick on canvas,
249 x 289.5 cm (98 x 114 in.)

Here Basquiat achieves a sparsity and clarity of technique possibly greater than in any other work, making it one of the greatest paintings in his oeuvre and not just by virtue of the artist's imminent death.

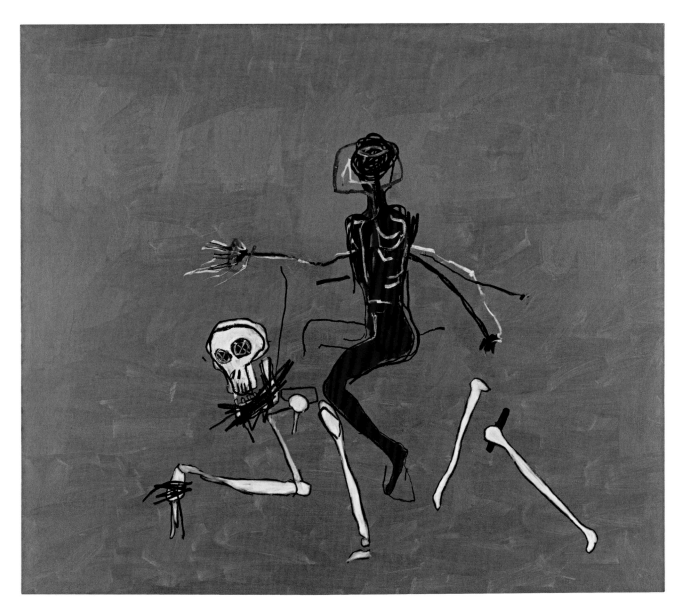

Eroica I, 1988
Acrylic and oilstick on paper mounted
on canvas, 230 x 225.5 cm (90½ x 88¾ in.)

Eroica II, 1988
Acrylic and oilstick on paper mounted
on canvas, 230 x 225.5 cm (90½ x 88¾ in.)

Untitled (Leonardo and His Five Grotesque Heads), 1983
Acrylic and oilstick on canvas,
214 x 214 cm (84¼ x 84¼ in.)

PAGE 85
Pharynx, 1985
Acrylic, oilstick and collage on paper,
218.5 x 172.5 cm (86 x 68 in.)

Over and over it repeats the words "Man Dies," accompanied by a talon-like symbol. This symbol is a hobo sign from the *Symbol Sourcebook* collected by Henry Dreyfuss (ill. p. 79), one of Basquiat's most prized books. In his 1987 painting *Riddle Me This Batman,* Basquiat used another sign from this collection, which meant: "Nothing to be gained here." Again it seems like an omen that Basquiat in 1987 had his picture taken in front of this painting, the large hobo sign to his right, as though giving expression to his disappointment and disillusionment. In times past, American hobos had drawn these cryptic signs on walls to inform other hobos about the dangers or enticements of certain places and their inhabitants.

Basquiat's extensive use of the Dreyfuss book is also evident in the collage *Pegasus* (ill. p. 80 top), a galaxy of logos and symbols of multiple origin and meaning. This work, which impresses with its radical coloration, shows an early appearance of the word "Eroica," a reference to Ludwig van Beethoven's famous Third Symphony. Next to the evocations of death and heroism – well known from Basquiat's earlier paintings with their readable polarities of heroism and martyrdom – *Eroica I* and *Eroica II* (ill. pp. 82 and 83) use text from encyclopedias. Basquiat called these verbal collage bits his "Facts"; they not only label, they actually represent the diversity of the world and its manifestations. *Eroica I* and *Eroica II* therefore are not so much documents of a death premonition as essays on the fundamental tragedy of the human condition – which must find a place somewhere between the heights of heroism and the inevitability of death, somewhere in the routine chaos, the banality of daily life.

Speculations about premonitions of death in his final paintings neatly ignore that death played a dominant role in Basquiat's paintings and drawings from the very beginning of his career. His countless skeletons and skulls can hardly be passed off as formal citations of anatomy books. They bespoke a veritable obsession with death, which runs through all of Basquiat's work. Of course, much of what he painted was repetitive; he constantly reprised earlier inventions, especially those that sold well on the art market and that had advanced to trademarks. But Basquiats countless depictions of skeletonized or transparent x-rayed bodies show that his own physicality and mortality were central issues of his work.

The high point of this death obsession is achieved perhaps in Basquiat's final year with *Riding with Death* (ill. p. 81), no doubt one of his last paintings. On a lightly modulated olive-green background, a brown-colored figure rides on the back of a human skeleton, which leaps up on its hands and knees. The frugal technique, the reduction and simultaneous clarity of the subject, and the avoidance of anything sentimental or commercial make this one of the most impressive and best paintings in his entire oeuvre. Here the matter of death is so obvious that again, it is difficult not to read the painting as a premonition of his own imminent demise. But again, we must note that Basquiat's vulnerable life (as Vincent Gallo called it) on many occasions had already been exactly that: a ride with death.

The figures in *Riding with Death* are adopted directly from an allegorical drawing by da Vinci. Basquiat's admiration for Leonardo is well documented, and he often cited the works of the Renaissance artist. The *Untitled* of 1985 adopts a Maria lactans and an excerpt from Leonardo's discourse on painting. The mere title of *Leonardo da Vinci's Greatest Hits,* from 1982, is clear enough, and another *Untitled (Leonardo and His Five Grotesque Heads)* from 1983 (ill. p. 84 top) reprises da Vinci's famous drawings of grotesque heads, which

Burchard Brentjes: *African Rock Art,* 1969

BLOOD
FECES
URINE
~~MUCOS~~
~~BILE~~

85

Leonardo described as "alter egos." Basquiat often adapted da Vinci's word lists and technical drawings. The line configurations in *Notary* (ill. pp. 24/25) can be understood as charts of constellations and may be associated with the planet Pluto, but similar configurations occur in other paintings that directly cite da Vinci's drawings of rolling mills and other technical devices. And surely the old master's anatomical drawings must have made a great impression on Basquiat, without which the running motif of the skeletonized body in his works becomes inconceivable.

Little talk or text was devoted to Basquiat's work in the mid-1990s. The painting euphoria of the 1980s, which arose with Basquiat, Eric Fischl and Julian Schnabel as its figureheads in the United States, Georg Baselitz, Anselm Kiefer and Markus Lüpertz in Germany, and Enzo Cucchi, Francesco Clemente and Sandro Chia in Italy, has now gone into reverse. As though the art business is in the grip of a secret shame at the excesses of the 1980s, the term Neo-Expressionism tends to no longer even be mentioned.

Richard Marshall organized an excellent 1992 retrospective at the Whitney Museum of American Art in New York, which went on to tour several American museums through 1994. The last of the critical treatments of Basquiat's

Marmaduke, 1985
Acrylic, oilstick, photocopy collage, and paper collage on wood, diptych: 203 x 259 cm (80 x 102 in.)

*Defacement (The Death of
Michael Stewart),* 1983
Acrylic and marker on board,
63.5 x 77.5 cm (25 x 30½ in.)

Basquiat confronts racism in this painting
memorializing the murder of the black graffiti
sprayer Michael Stewart by white policemen.

works date back to that time. Various exhibitions and publications have since
served to make his works accessible to a general public, but tend to go no fur-
ther than the simplistic portrayal of Basquiat as "Black Picasso" and the reprint-
ing of sentimental recollections from gallerists and others who knew him
personally.

With his 1996 film *Basquiat,* Julian Schnabel completed the process of trans-
forming Jean-Michel Basquiat into myth and permanently robbing him of his
relevance. Schnabel's reduction of Basquiat to a color-spurting genius in bath-
robe, a smart young black guy who unfortunately took too many drugs and had
the bad luck to die from them, once again reproduces the cliché of the tragically
failing artist. Holland Carter blasted the film's effects in a *New York Times* review
of November 1, 1996, writing: "Jean-Michel Basquiat (1960–1988) did a lot of
people a lot of favors. He gave Julian Schnabel a film. He gave a 50-something
Andy Warhol acceptance by association into the art world of the 1980s. And, in
the view of some, he gave a fundamentally elitist and racist New York art world a
risk-free chance to embrace a black artist. The embrace was, of course, entirely
on the art world's terms. No need for dealers or critics to venture into Harlem
or the barrio."

Untitled (Famous Moon King), 1984
Watercolor and pencil on paper,
60.3 x 48.2 cm (23¾ x 19 in.)

Although critical and scholarly treatment of his work has declined, the
prices continue to rise. At the Sotheby's auction of November 17, 1997, *Untitled*
(*Baptism*; 1982) was sold for a cool $1.4 million. The *New York Times* reported
on November 13, 1998, that Basquiat's *Self-Portrait* of 1982 (ill. p. 44) had been
sold for a record $3.3 million. And on May 14, 2002, Christie's in New York
auctioned *Profit I* (ill. pp. 46/47) for an incredible $5.5 million. In 2008 the
painting *Untitled* (*Boxer,* 1982) went to a new owner for $13.5 million; in 2013
the work *Dustheads* (1982) was auctioned at Christie's, reaching a price of
$48.8 million, and in 2017 *Untitled* (1982) was sold at Sotheby's for fabulous
$110 million!

Toussaint l'Overture versus Savonarola, 1983
Acrylic, oilstick, and photocopy
collage on canvas, polyptych:
122 x 584 cm (48 x 230 in.)

No doubt we rightly see Basquiat's work as part of a trend towards reviving the categories of originality, primitivity, authenticity, attempting through them to renew and revitalize art itself. Not by coincidence did A. R. Penck discern a soulmate in Basquiat, for he too sought after a form of art that all could understand, indeed that all could practice, and he too reduced his visual inventory to simple symbols and stick figures.

But the style of Basquiat's work in many ways takes an eclectic mannerist, postmodernist approach that has little to do with programmatic primitivism à la Penck or Dubuffet. His "Facts" are false readymades, similar to the imitations of torn-down posters presented by the French Nouveau Realistes. A painting like *Marmaduke* (1985, ill. p. 86) has more in common with a work by Clyfford Still than with the intentional and calculated primitivity of those who hope to discover the antidote for the poison of a corrupting culture in the raw and the pure. Certainly Basquiat understood the shadowy side of that culture, and he felt its deprivations on his own body.

There is no other way to see a caption like "Disease Culture," which appears once with a Spanish question mark and once as a statement in the 1982 painting *K*. Next to artists he admired like Twombly, Franz Kline and Leonardo da Vinci, he sought models from African rock painting. The female figure in *Untitled* (1984), *Untitled* (1986) and *Pharynx* (1985, ill. p. 85) is taken directly from the figure of a queen depicted by the African tribe of the Dende-maro, as reproduced in Burchard Brentjes' *African Rock Art* (ill. p. 84 bottom). And the reclining woman in the 1984 drawing *Untitled* (*Famous Moon King;* ill. p. 87 bottom) similarly adapts a rock painting from Rhodesia.

From the start, Basquiat put the problem of race at the center of his art. This is attested to by countless works deriving from Black history, like *Undiscovered Genius of the Mississippi Delta* from 1983, *Untitled (History of Black People)* from 1983, and *Slave Auction* from 1982, as well as by his reaction to the fate of the graffiti sprayer Michael Stewart, who was beaten to death by white cops on September 15, 1983: *Defacement* (*The Death of Michael Stewart;* 1983, ill. p. 87 top). But only towards the end of his life did he begin to feel positive about his

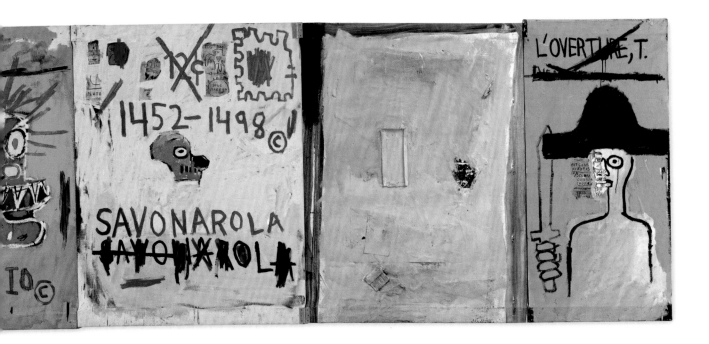

own racial identity, as the awakening of his interest in Africa by Shenge ka Pharaoh and Ouattara shows.

Toussaint L'Overture versus Savonarola (1983, ill. pp. 88/89) bears witness to the precision and consistency with which Basquiat explored Black history. Consisting of seven individual sections, this work documents his stylistic range from expressive painting to conceptual collage and color-field painting, as it describes two revolutionaries from European and American history: the Florentine preacher Savonarola (1452–1498), who attempted to set up a kind of theocracy, and the liberator of the former French colony of Haiti, Toussant L'Overture, who was born in 1743 and died in 1803 after his capture and imprisonment from the tortures inflicted on him in Doubs. The title underlines the contradiction between the races, much like the caption "Malcolm X versus Al Jolson," which contrasts the Black Muslim leader Malcolm X (1925–1965) with the white Jazz singer in blackface, Al Jolson (1886–1950).

Malcolm X, the harshest opponent of American society, is taken as a positive opposite pole to Jolson, a plagiarizer of "black" jazz who by his performances for American GIs in Korea perverted the music of the oppressed into an official state art form. But there is no similar clear opposition between L'Overture and Savonarola.

The "versus" of this title is more in the sense of a hip-hop battle, in which various MCs and DJs step up to outperform each other. Both Toussant and Savonarola were victims, the latter of a corrupt and decadent papacy, just like Galileo Galilei (the subject of another Basquiat work from 1983). L'Overture was done in by the French colonial power, which may have proclaimed the idea of liberty, equality and fraternity in the French Revolution of 1789, but which proved not the least willing to abolish slavery.

Basquiat's work thus documents the progressive construction of the artist's discordant identity, of a man grappling with the reality that he could make little use of the patterns available to him – either of his father's existence as an accountant who adopted the ideals of the white middle class, or the ghetto kid attitude of the graffiti sprayer. Basquiat's numerous self-portraits may well be

Glassnose, 1987
Acrylic on canvas, 168 x 145 cm (66¼ x 57 in.)

Portrait of the Artist as a Young Derelict, 1982
Acrylic, oil, ink, and oilstick on wood,
triptych: 204 x 208.5 cm (80 x 82 in.)

ideal blueprints of the artist as enraged hero; but they are also terrifyingly bleak documents of inner turmoil and great loneliness. His *Portrait of the Artist as a Young Derelict* (1982, ill. p. 91) plays a maudlin game with the possibility of failure, a contrast to the struggle against the "many voices," against the splintering of his own self due to the "pure difficulty of living in the differences" evident in his self-portraits. The painting *To Repel Ghosts* (1986, ill. p. 90) is not just a wordplay on the idea of rebellious spirits, but also an appeal to his own power to resist the many different ghosts that dominate and propel Jean-Michel Basquiat himself.

Writing in the catalogue text of the second Mary Boone exhibition, Robert Farris Thompson used the idea of Creole to describe Basquiat's art. Jean Bernabé, Patrick Chamoiseau and Raphaël Confiant wrote a French-language treatise entitled "Elegy to Creole" in 1989, a text that has acquired increasing cachet in the art discourse after the turn of the century along with the term itself. One of the academic "platforms" leading up to documenta 11 in 2002 in Kassel is devoted exclusively to discussion of this term and its usefulness in understanding current political and cultural events. Creole is derived from the Portuguese word "crioulo," meaning a person of originally European descent who was born and grew up in a colony. Creole describes the various languages that arose starting 300 years ago in the interaction between European, African and indigenous idioms, meeting the need for communication between European settlers, African slaves of often very diverse origins, and the native populations in each colony.

The idea of Creole is excellently suited to rescuing Basquiat from the narrow confines of Neo-Expressionism and liberating him from the programmatic labels of authenticity and originality. How much more fruitful to see his art as a thoughtful reflection on the diversity of the influences to which he was subjected, and to associate this attitude in turn with emergent postmodernist currents, than to isolate him simplistically (in Luca Marenzi's ill-chosen words) as the "only black artist who left a notable imprint on the history of art" – especially given how the latter conclusion merely repeats and reiterates the latent racism and ignorance of an art-historical scholarship centered entirely on Europe and America.

That having been said, many of Jean-Michel Basquiat's works are among the most powerful and intense to come out of the 1980s art scene. The uniqueness of his work has served to keep it from having a recognizable influence on painting in the years since his death. He remains an astonishing solitaire in the history of painting.

To Repel Ghosts, 1986
Acrylic on wood, 112 x 83 x 10 cm
(44 x 32¾ x 4 in.)

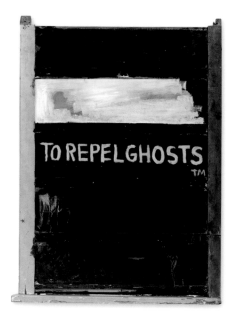

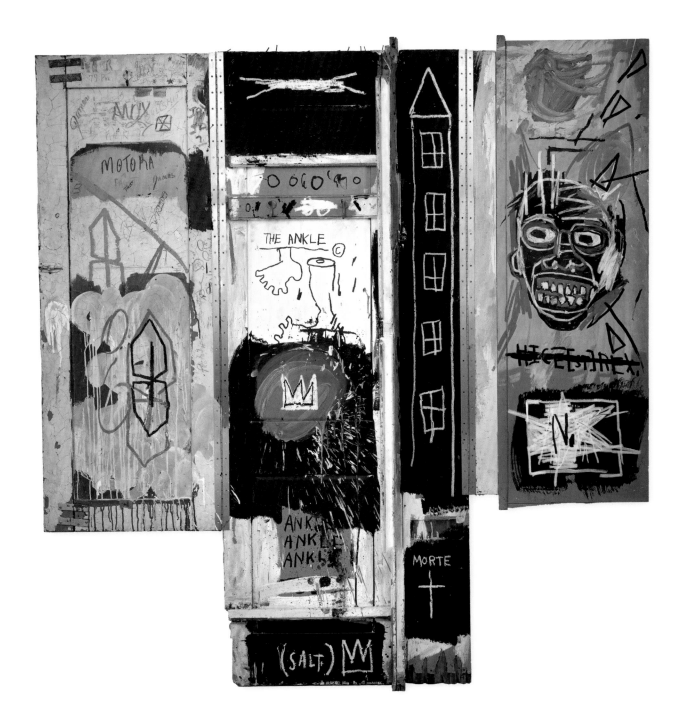

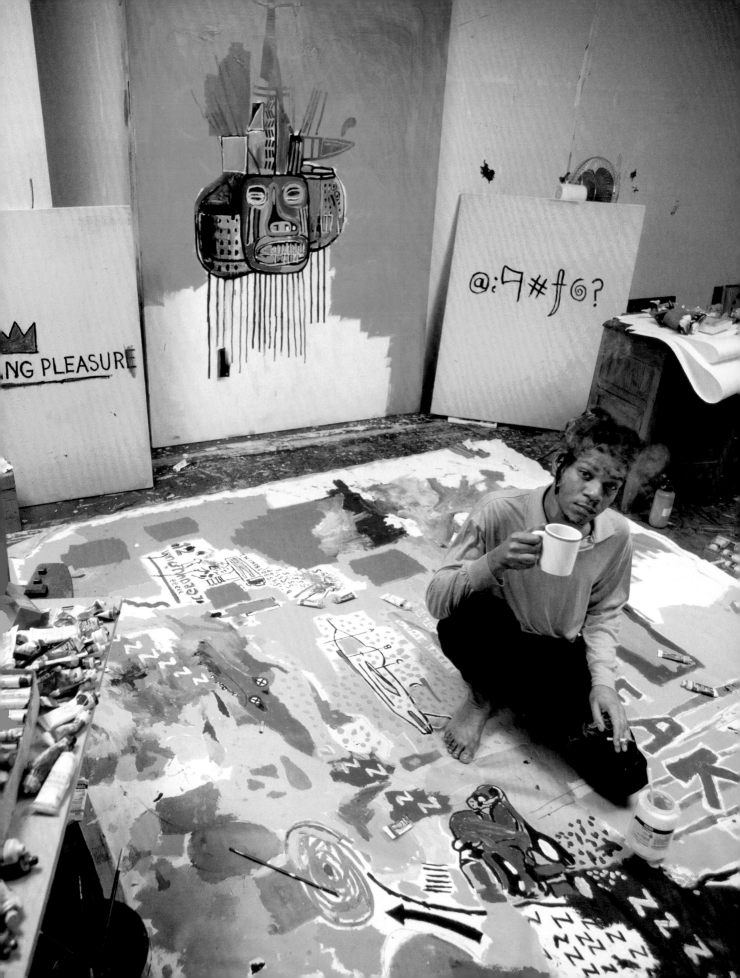

Jean-Michel Basquiat
1960–1988
Life and Work

1960 Jean-Michel Basquiat is born in Brooklyn Hospital, New York City, on December 22. The family lives in Park Slope, Brooklyn. His father Gerard is from Port-au-Prince, Haiti. His mother Matilde, the daughter of Puerto Rican parents, is from Brooklyn. His father works as an accountant in New Jersey.

1963 Basquiat's sister Lisane is born.

1967 Basquiat's sister Jeanine is born. Matilde, who is interested in fashion design and draws together with her son, takes him on visits to the Metropolitan Museum, the Brooklyn Museum and the Museum of Modern Art. The children learn Spanish, French and English. Jean-Michel starts attending St. Ann's, a Catholic private school. He writes and draws a children's book together with a school friend.

1968 Jean-Michel is hit by a car and suffers a broken arm as well as internal injuries, forcing the removal of his spleen. To pass the time in the hospital, his mother brings him a copy of *Gray's Anatomy*. His parents divorce. His father moves with his three children first to Flatbush, then to Boerum Hill. Jean-Michel's relationship with his father becomes increasingly difficult.

1974–75 Gerard Basquiat takes a position in Miramar, Puerto Rico, and moves there with his children. Jean-Michel runs away from home for the first time.

1976 After the family's return from Puerto Rico to New York City, Jean-Michel attends a series of schools, always only for a short time and with poor grades. He has a succession of conflicts with his father. In December he again runs away from home. The police finally find him in Washington Square Park and bring him back home.

1977 After attending a series of public schools, Jean-Michel finally lands at City-As-School, a liberal institution for gifted children with integration difficulties. Together with Al Diaz, Jean-Michel invents the comic figure SAMO. Using this pseudonym, he signs his graffiti in downtown Manhattan. The *SoHo News* publishes photos of his wall spraying, making it far better known.

1978 The conflicts between Gerard and Jean-Michel escalate. One year before his graduation, Jean-Michel drops out of the City-As-School and runs away from home for good in June. He earns some money through the sale of collage postcards and painted T-shirts. First attempts to become acquainted with Andy Warhol. Basquiat lives without a fixed address and occasionally peddles his body for money. A blonde mohawk helps in his sudden and rapid rise as a known club-goer. Soon he is a fixture among the scene artists, musicians and filmmakers at nightclubs like the Mudd Club and Club 57. On December 11, the *Village Voice* publishes an interview with Jean-Michel Basquiat and Al Diaz, in which they reveal themselves as the creators of SAMO.

1979 Dispute with Al Diaz, after which the slogan "SAMO is dead" appears on the walls of SoHo. In May, Basquiat founds a band together with Michael Holman, Sharon Dawson and Vincent Gallo. They go through several names before settling on Gray, which plays art-noise at the same clubs where Basquiat sometimes works as a DJ. Basquiat makes the acquaintance of Keith Haring and Kenny Scharf, and also meets Glenn O'Brien, music editor of *Interview*

James Van Der Zee
Basquiat, New York, 1982
© Donna Mussenden Van Der Zee

and host of a cable TV show on which Basquiat often appears. Basquiat comes to know one of the founders of the Mudd Club, the filmmaker and musician Diego Cortez.

1980 Cortez invites him to take part in the "Times Square Show," a large group exhibition in an empty building at Times Square that also includes Jenny Holzer, Kenny Scharf and Kiki Smith. Basquiat breaks up with the band Gray. Basquiat plays the protagonist in the film *Downtown 81* (first released in 2000), produced by image-maker Maripol, directed by Edo Bertoglio and written by Glenn O'Brien. His earnings from that allow him for the first time to purchase materials for painting. He finds just enough

Jean-Michel Basquiat in his Great Jones Street studio, New York 1987
Photo Tseng Kwong Chi

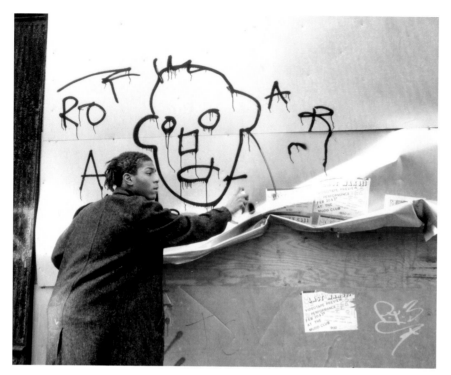

space to begin painting at the film production office on Great Jones Street.

1981 Basquiat moves into an apartment at 68 East 1st Street together with Suzanne Mallouk. Cortez invites him to take part in the "New York/New Wave" exhibition at P.S.1 in Long Island City. Cortez fixes him up with the Swiss gallerist Bruno Bischofberger, and with the Italian Emilio Mazzoli, who invites Basquiat to his first one-man show under the SAMO name in Modena that May. In April, Basquiat takes part in "Beyond Words: Graffiti-Based, -Rooted, and -Inspired Works" at the Mudd Club. Gallerist Annina Nosei invites him to take part in the "Public Address" show that September and October and lets him set up a studio in the basement of her gallery. In December, René Ricard gives Basquiat's reputation a decisive boost with an essay in *Artforum,* "The Radiant Child."

1982 Basquiat travels to Culebra, Puerto Rico. He has his first one-man show in the United States in March, at Annina Nosei's gallery. At her suggestion he shows his first series of silk-screen prints, titled *Anatomy.* Annina Nosei's business partner, Larry Gagosian, invites Basquiat to a show in Los Angeles, where he goes in April. He ends up staying in California for six months. Basquiat's work is exhibited in several group shows. In Modena, the "Transavanguardia Italia/America" show features works by Basquiat, Sandro Chia, Francesco Clemente, David Salle, Julian Schnabel and others. That summer, several Basquiat works are shown at documenta 7 in Kassel. His first one-man show in Zurich

follows in September, after his break with Annina Nosei. Bruno Bischofberger introduces Basquiat to Andy Warhol in October. His show at the Fun Gallery in November meets with universal praise. He spends the winter of 1982–83 in Los Angeles, where he prints his second series and produces and directs the album *Beat Bop.* In December, the Delta Gallery in Rotterdam shows works by Basquiat.

1983 Shenge Ka Pharoah, an artist originally from Barbados, becomes Basquiat's assistant. Simultaneous to the second exhibition at Gagosian's in Los Angeles, the Whitney Museum of American Art includes Basquiat works in its Biennial. Through Paige Powell, Basquiat gets closer to Warhol and on August 15 moves into a studio on Great Jones Street, which he rents from Warhol and uses until his death. In October, Basquiat and Warhol travel together to Milan. Basquiat continues to Madrid and Zurich and flies to Tokyo in November for the opening of his show at the Akira Ikeda Gallery. Subsequently he begins a collaboration with Francesco Clemente and Andy Warhol, as arranged by his gallerist Bruno Bischofberger. Basquiat again spends the winter in Los Angeles, renting a studio in Venice. Around this time he has a short affair with Madonna.

1984 From Los Angeles, Basquiat travels for the first time to Maui, where he rents a ranch to which he returns several times. There he is visited by Paige Powell, his sisters, his father and his father's partner, Nora Fitzpatrick. After his return to New York, Basquiat begins working with

gallerist Mary Boone, who has dealt Eric Fischl, David Salle and Julian Schnabel. The first Boone show follows in May. Basquiat's first one-man museum show is staged in August at the Fruitmarket Gallery in Edinburgh, and tours London and Rotterdam. Bischofberger presents the *Collaborations* between Basquiat, Clemente and Warhol in September, but most of the critics give it a thumbs-down. Warhol and Basquiat continue to work on joint projects. Two Basquiat works are included in the show "Since the Harlem Renaissance: 50 Years of Afro-American Art" at Bucknell University in Lewisburg, Pennsylvania. Towards the end of the year, Jean-Michel begins a relationship with Jennifer Goode.

1985 Henry Geldzahler arranges for him to paint a wall at the newly opened Palladium. The Warhol-Basquiat collaborative show at Bischofberger's in September receives a near-unanimous critical panning, leading to a break between the two artists. Concurrently with Basquiat's second one-man show at Akira Ikeda's in Tokyo, Annina Nosei puts on a show in New York of his works from the year 1982.

1986 Basquiat spends January in Los Angeles, preparing a show for Gagosian. He travels to Africa together with Jennifer Goode and the Bischofbergers. Bischofberger arranges a show for him in Abidjan, Ivory Coast. The Kestner Society in Hannover puts on a large retrospective show. Basquiat meets William S. Burroughs. He fires Shenge Ka Pharoah, who had begun to paint and was accused by Basquiat of imitating him. The final break with Mary Boone comes towards the end of the year, and Jennifer Goode breaks up with him.

TOP LEFT
Jean-Michel Basquiat on the set of *New York Beat / Downtown 81*, New York 198/81
Photo Edo Bertoglio

Andy Warhol, Jean-Michel Basquiat, Bruno Bischofberger, Francesco Clemente, New York, 1984

1987 Andy Warhol dies on February 22. For several weeks Basquiat is inconsolable. Through Tony Shafrazi he meets his last dealer, Shafrazi's cousin Vrej Baghoomian.

1988 Basquiat has shows in Paris at Yvon Lambert's and in Düsseldorf at Hans Mayer's. In Paris, he meets Ouattara, a painter from Ivory Coast. In April, Basquiat travels to his ranch in Maui. The New York show earns his first positive reviews in years. A few days before his flight to Abidjan, Jean-Michel Basquiat dies on August 12 from an overdose. He is buried at the Greenwood Cemetery in Brooklyn on August 17. Three hundred people attend a memorial service for Basquiat at St. Peter's Church on November 5.

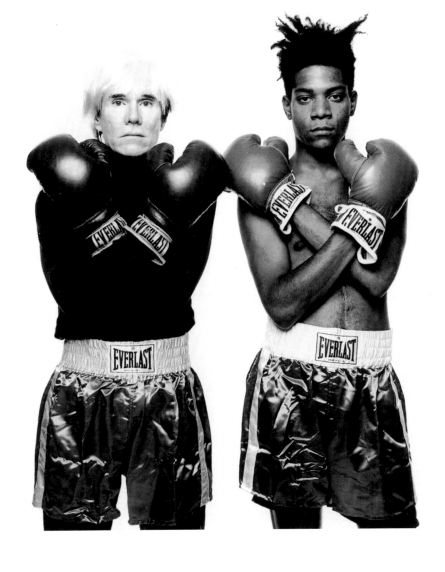

Michael Halsband
Warhol and Basquiat, 1985
Photograph for exhibition at Tony Shafrazi Gallery, New York
© Michael Halsband

Selected bibliography

Basquiat – Drawings (exhibition catalog) Robert Miller Gallery, New York 1990

Jean-Michel Basquiat (exhibition catalog) Whitney Museum of American Art, New York 1992/93

Collaborations Warhol, Basquiat, Clemente, (exhibition catalog), Museum Fridericianum, Kassel; Museum Villa Stuck, Munich 1996

Jean-Michel Basquiat (monograph) Galerie Enrico Navarra, Paris 1996, 2000

Jean-Michel Basquiat, (exhibition catalog), Musée Maillol, Fondation Dina Vierny, Paris 1997

Jean-Michel Basquiat (exhibition catalog) Edizione Charta, Triest 1999

Jean-Michel Basquiat (exhibition catalog) Museum Würth, Künzelsau 2001

Collaborations Warhol, Basquiat, Clemente (exhibition catalog) Museo Nacional, Centro de Arte Reina Sofía, Madrid, 2002

Basquiat – In Word Only (exhibition catalog) Cheim & Read Gallery, New York 2005

Basquiat – Retrospective (exhibition catalog) The Brooklyn Museum of Art, New York, The Museum of Contemporary Art, Los Angeles, The Museum of Fine Arts, Houston and La Triennale di Milano, 2005/2006

Jean-Michel Basquiat (exhibition catalog) Fondation Beyeler, Basel 2010

Street and Studio. From Basquiat to Séripop (exhibition catalog), Vienna 2010

Jean-Michel Baquiat: The Unknown Notebooks (exhibition catalog), The Brooklyn Museum of Art, New York 2015

Basquiat – Boom for Real, Ausstellungskatalog Barbican Art Gallery, London / Schirn Kunsthalle Frankfurt, Munich 2017

Hans Werner Holzwarth, Eleanor Nairne, *Jean-Michel Basquiat* (monograph), TASCHEN, Cologne 2018

Acknowledgements & photo credits

The publisher wishes to thank the museums, private collections, archives and photographers who granted permission to reproduce works and gave support in the making of the book. Special thanks to the Estate of Jean-Michel Basquiat / Museum Masters International, New York; to Tony Shafrazi Gallery, New York; and to Galerie Enrico Navarra, Paris.
If not otherwise specified, the reproductions originated from the archives of the publisher or the author. The copyright of the works illustrated, if not otherwise indicated, is held by the artists, their heirs or estates, or their assignees.

© The Estate of Jean-Michel Basquiat. Licensed by Artestar, New York: 6, 10, 11, 16 bottom, 28 bottom, 33, 38/39, 41, 46/47, 50, 58 top, 64/65, 70, 71, 87 bottom.
Private Collection, courtesy Acquavella Galleries; photo Kent Pell: 4, 56.
© Adagp Images, Paris/Scala, Florence: 26, 31.
© Banque d'Images, Paris: 23 top.
Bischofberger Collection, Mannedorf-Zurich, Switzerland: 17, 37 (Private Collection), 48, 62 bottom, 84 top, 88/89 (Private Collection).
Courtesy the Brant Foundation, Greenwich, CT, USA: 18/19, 34 top.
Private Collection, courtesy Galerie Andrea Caratsch, St. Moritz: 22, 72.
© Christie's Images/Bridgeman Images: 20 bottom, 21.
Henry Flynt, *The SAMO© Graffiti Portfolio*, 1979: 8 bottom.
Courtesy Gagosian: 29.
© Michael Halsband: 95.

Private Collection, courtesy Hamiltons Gallery: 82, 83.
© Lizzie Himmel, New York: 2, back cover.
Purchase of the American Friends of The Israel Museum Collection, The Israel Museum, Jerusalem/Photo by Avshalom Avital: 51.
Courtesy Kunsthalle Weishaupt: 78.
Courtesy Lio Malca: 42.
Rob McKeever, courtesy Gagosian: 40, 44, 49, 81.
Mugrabi Collection: 89.
Museo Guggenheim, Bilbao: 61.
Private Collection, courtesy Nahmad Contemporary: 90.
Courtesy Galerie Enrico Navarra, Paris: 14, 53, 54/55, 57, 60, 62 top, 80 bottom.
© New York Beat Films, LLC. Courtesy The Estate of Jean-Michel Basquiat: 9, 94 top.
Image courtesy Phillips Auctioneers LLC. All rights reserved: 76/77.
Beth Phillips: 27.
Princeton University Art Museum, New Jersey, Courtesy the Schorr Family Collection: 12/13.
Private Collection: front cover, 32 bottom, 67, 75, 91.
© Scala, Florence: 63.
Courtesy Tony Shafrazi Gallery, New York: 24/25, 30, 32 top, 36, 45, 52, 66, 68, 69, 80 top.
Private Collection, courtesy Tajan SA: 86.
Nicholas Taylor: 23 bottom.
Photograph by Tseng Kwong Chi. © 1987 Muna Tseng Dance Projects, Inc. New York. www.tsengkwongchi.com: 92.
© 2003 Andy Warhol Foundation for the Visual Arts/ARS, New York: 70, 71.
© Donna Mussenden Van Der Zee: 93.

The author

Leonhard Emmerling received his doctorate from the University of Heidelberg for a thesis titled "Jean Dubuffet's Art Theory." He is the Director of South Asia Programmes at the Goethe Institute's office in New Delhi and was previously active as a curator at various art institutions in Germany. His publications include TASCHEN's *Jean-Michel Basquiat* and *Jackson Pollock*.

Imprint

EACH AND EVERY TASCHEN BOOK PLANTS A SEED!
TASCHEN is a carbon neutral publisher. Each year, we offset our annual carbon emissions with carbon credits at the Instituto Terra, a reforestation program in Minas Gerais, Brazil, founded by Lélia and Sebastião Salgado. To find out more about this ecological partnership, please check: www.taschen.com/zerocarbon
Inspiration: unlimited.
Carbon footprint: zero.

To stay informed about TASCHEN and our upcoming titles, please subscribe to our free magazine at www.taschen.com/magazine, follow us on Instagram and Facebook, or e-mail your questions to contact@taschen.com.

© 2021 TASCHEN GmbH
Hohenzollernring 53, D–50672 Köln
www.taschen.com

Original edition: © 2003 TASCHEN GmbH

© The Estate of Jean-Michel Basquiat. Licensed by Artestar, New York.

Translation: Nicholas Levis, Berlin

Printed in Slovakia
ISBN 978-3-8365-5979-9

FRONT COVER
Glenn, 1984
Acrylic, oilstick, and photocopy collage on canvas, 254 x 289.5 cm (100 x 114 in.)

BACK COVER AND PAGE 2
Jean-Michel Basquiat in his Great Jones Street studio, New York 1985

PAGE 4
The Ring, 1981
Acrylic and oilstick on canvas, 152.5 x 122 cm (60 x 48 in.)